THEN & NOW®

ST. PETERSBURG

OPPOSITE: St. Petersburg was once famous for its green benches, which were placed along Central Avenue and many downtown streets. They began with Noel A. Mitchell, one of the first mayors, in front of his real estate office. By 1950, there were 7,000 to 8,000 green benches throughout the city. By the 1960s, the city council was concerned with the city's image and pressed for a more youthful look. In 1967, an ordinance was passed to remove all of the benches from the city. (Courtesy Tampa–Hillsborough County Public Library System.)

ST. PETERSBURG

Sara O'Brien

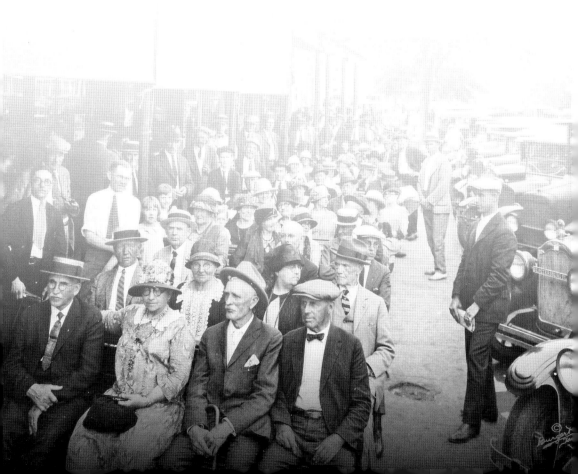

For my parents, Dave and Diane,
who've never stood in the way of my path,
only cheered me on along my journey.
You are true inspirations. I love you.

Copyright © 2009 by Sara O'Brien
ISBN 978-0-7385-6767-9

Library of Congress Control Number: 2009920588

Published by Arcadia Publishing
Charleston, South Carolina

Printed in the United States of America

Then and Now is a registered trademark and is used under license from
Salamander Books Limited

For all general information contact Arcadia Publishing at:
Telephone 843-853-2070
Fax 843-853-0044
E-mail sales@arcadiapublishing.com
For customer service and orders:
Toll-Free 1-888-313-2665

Visit us on the Internet at www.arcadiapublishing.com

On the Front Cover: Spa Beach and the Pier have always been staples of the St. Petersburg landscape. This area of downtown displays what St. Petersburg represents. It is a place to bask in the sun, relax in the sand, or take in the countless array of activities that the "Sunshine City" has to offer. (Historic image courtesy Heritage Village Archives and Library; Now image courtesy the author.)

On the Back Cover: Built in 1924, the Coliseum quickly became known as the "finest ballroom in the south." The Coliseum is still used for various occasions today. (Courtesy Tampa–Hillsborough County Public Library System.)

CONTENTS

ACKNOWLEDGMENTS

A huge amount of gratitude must be given to those individuals who have helped make this book possible. These individuals went above and beyond to offer their services, knowledge, and support throughout the creation of this book.

I would like to thank Adele Gilmore, who not only lent me many postcards from her collection, but also put me in touch with valuable contacts like author Winelle Deese. Winelle shared personal insight and knowledge, having worked on many similar projects herself.

David Parsons, a librarian for the Tampa–Hillsborough County Public Library System, was very generous with the resources available at the John F. Germany Public Library in downtown Tampa. On several occasions, he spent time gathering and scanning images for this project in both a careful and timely manner.

Alison Giesen, curator of collections for the Heritage Village Archives and Library, was of great assistance, as were several of her volunteers, who also offered their time and expertise.

Also, thank you to Linda Kinsey of the City of St. Petersburg Marketing Department; Anne Wykoff, archivist at the St. Petersburg Museum of History; Sherry Ferguson, who searched her house many times over trying to find a photograph for me; Sherry's husband, Mark, owner of Ferg's Sports Bar; Dave Mamber Sr., owner of Dave's Aqua Lounge; Hank Barlas, owner of Coney Island Grill; Jill Frers, owner of Chattaway's, and finally, Ed and Karen Yarb, for sharing a piece of their family history with me.

Last, but not least, I'd like to thank my close friend Betsy Wickham, who supported me and kept me motivated throughout this wonderful journey.

All modern images were taken by the author.

INTRODUCTION

The history of St. Petersburg dates back to 1875, when Gen. John Williams came down from Detroit, Michigan, and bought 2,500 acres of land on Tampa Bay. The city's first hotel, the Detroit Hotel—named after General Williams's birthplace—still stands today.

Thirteen years later, Williams transferred part of his land to a Russian aristocrat named Peter Demens. In return, Demens brought the Orange Belt Railway to St. Petersburg, and as part of the deal, Williams agreed to let Demens name the settlement St. Petersburg, after his Russian birthplace. At that time, only about 30 people were believed to have settled in the area.

Two remarkable events happened in St. Petersburg during the year 1914. The city's former mayor Al Lang struck a deal with Branch Rickey to move his St. Louis Browns to St. Petersburg, helping to make the area the home of Major League Baseball spring training. Also that year, Tony Jannus flew his Benoist airboat across Tampa Bay in 23 minutes. The event marked St. Petersburg as the birthplace of commercial aviation.

Florida experienced its first population boom during the 1920s, bringing a multitude of tourists by way of automobile, railroad, and yacht. In 1924, the Gandy Bridge opened, allowing people to travel from St. Petersburg to Tampa in half the time. This boom also brought forward notable architecture to St. Petersburg. Entrepreneurs like C. Perry Snell, considered the premier boom developer, built a 275-acre subdivision and inspired the creation of several structures like the Vinoy Hotel, the Jungle Country Club Hotel, the Princess Martha, and the Snell Arcade. Some of these structures, which reflect a Mediterranean Revival motif, still stand today.

In the 1940s, St. Petersburg became home to the U.S. Coast Guard station on Bayboro Harbor, a training base for World War II troops. The War Department also selected St. Petersburg as a major technical services training center for the U.S. Army Air Corps. During this period, the population swelled, and the large number of military men staying in the area with their families created a housing shortage.

With the advent of air-conditioning in the 1950s, many retirees claimed Florida as a desirable place to live. The population stretched beyond 200,000, and the old streetcar tracks were removed to make way for more automobiles. New development in the 1960s included the Municipal Marina, the Bayfront Center, and the Museum of Fine Arts.

Many notable areas and structures still stake their claim in the soil of St. Petersburg. For example, the Don CeSar Hotel, built in 1928, was a famous spot for notables like F. Scott Fitzgerald, Clarence Darrow, and Al Capone.

Today St. Petersburg still remains much like the resort town that its founders enjoyed. Each year, more than 90 events bring over 10 million visitors to the area. As new structures decorate the skyline and the landscape continues to be remolded, the foundation of history in St. Petersburg remains vast and strong.

CHAPTER 1

HELLO CITY

Streets, Parks, and Neighborhoods

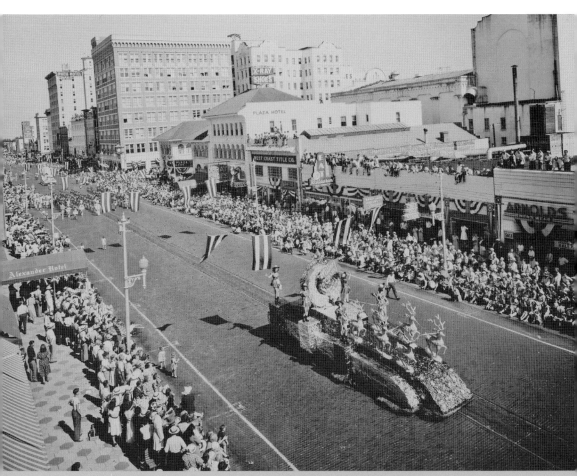

St. Petersburg began like most American cities: with dirt roads, small settlements, and wide-eyed entrepreneurs. As a city took on a life of its own, it is the legacies of landmarks from each generation that tell their stories. Here a fabulous shot of Central Avenue is captured by the Burgert Brothers in 1948 and shows the city of St. Petersburg celebrating a Festival of States parade. (Courtesy Tampa–Hillsborough County Public Library System.)

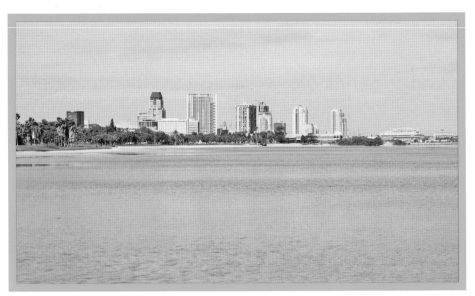

This postcard (below) dates back to the early 1900s and shows a glimpse of the old St. Petersburg skyline. Toward the right side of the postcard, the Detroit Hotel can be seen above all other structures. It was built in the late 1800s and was the first hotel in St. Petersburg. The above photograph shows a stark contrast from the early days and was taken from a piece of property overlooking Lassing Park. (Historic image courtesy Heritage Village Archives and Library.)

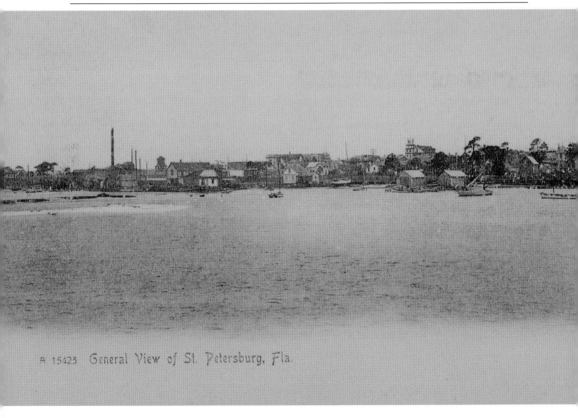

A 15423 General View of St. Petersburg, Fla.

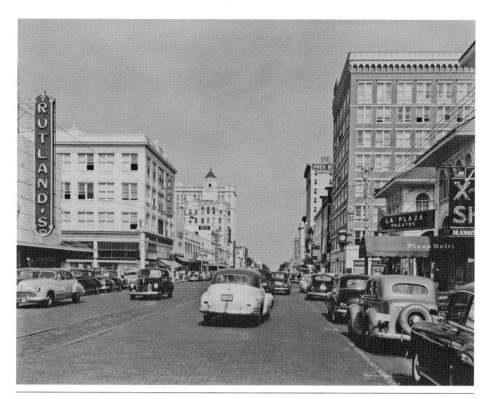

Central Avenue, shown above in 1949, is the main thoroughfare running directly down the center of downtown St. Petersburg. It is flanked by First Avenue North and First Avenue South, thus creating the foundation for the downtown grid. This area is known as the Grand Central District.

This historic image includes the Rutland and Kress Buildings on the left side of the street and the La Plaza Theatre on the right. (Historic image courtesy Tampa–Hillsborough County Public Library System.)

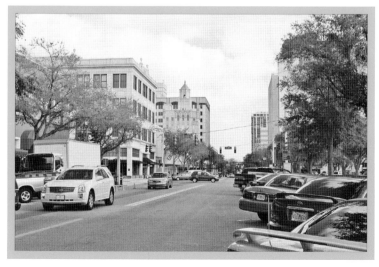

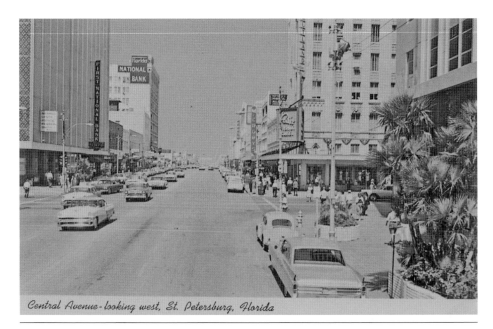

Central Avenue - looking west, St. Petersburg, Florida

This postcard portrays a busy day along St. Petersburg's Central Avenue facing west. On the left side of the street is the First National Bank, now the Bank of Wachovia, and on the right is the timeless Snell Arcade, built in the 1920s. Today Central Avenue and Fourth Street North is still one of the busiest intersections in the downtown area. (Historic image courtesy Adele Gilmore.)

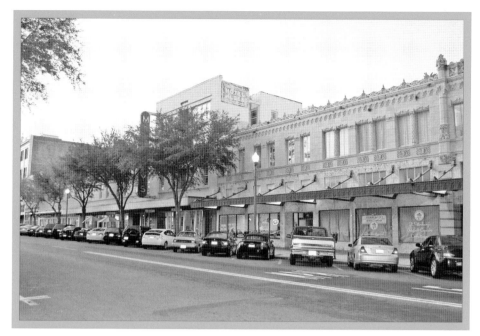

The Kress Building (below, at left), located at 475 Central Avenue, was part of the S. H. Kress and Company five-and-dime department store chain, built in 1927. Next to Kress is J. G. McCrory's, which was also a well-known chain with numerous stores throughout the country. The Rutland Building, which housed the Walgreen's pictured here, is also known as the Snell Arcade. Built in 1926, this building was placed on the National Register of Historic Places in 1982. (Historic image courtesy Adele Gilmore.)

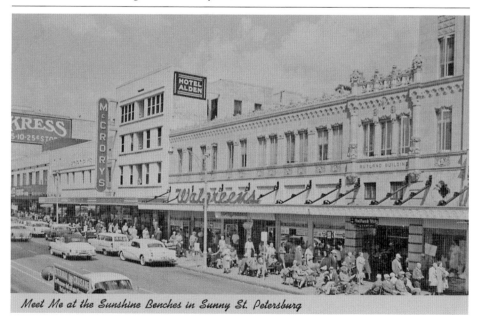

Meet Me at the Sunshine Benches in Sunny St. Petersburg

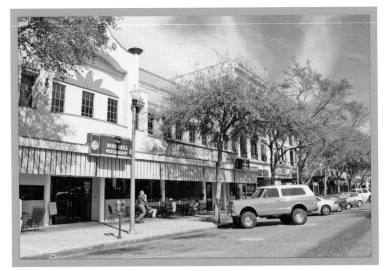

Another excellent view of Central Avenue, this time in 1950, includes a classic look at Woolworth's, as well as the famous green benches. Today this space is occupied by the Dome Grill Restaurant, famous for its inexpensive, tasty breakfast and pleasant street-side terrace seating. (Historic image courtesy Tampa–Hillsborough County Public Library System.)

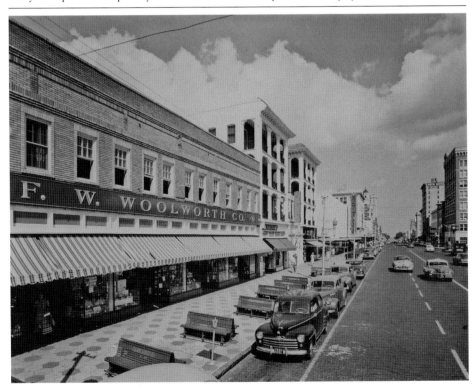

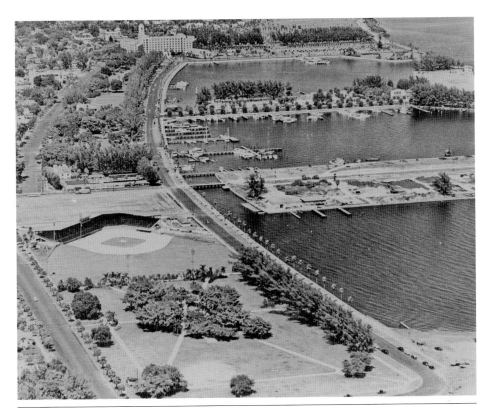

This historic aerial shot of St. Petersburg shows a largely underdeveloped downtown in the 1940s. In front is Al Lang Field, where many greats, like Babe Ruth, played spring baseball, and in the back is the historic Vinoy Hotel, built in the 1920s. The modern photograph includes Progress Energy Park and illustrates how the city has grown. With hotels, condominiums, banks, restaurants, and shops, St. Petersburg continues to expand. (Both images courtesy City of St. Petersburg.)

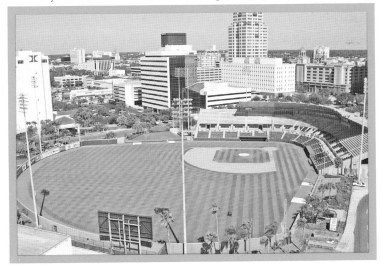

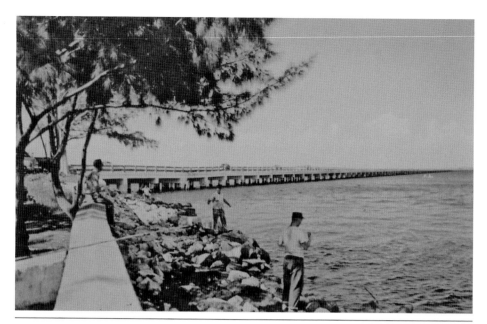

Construction of the original Gandy Bridge began in September 1922. At 2.5 miles long, it was the longest automobile toll bridge in the world at that time. The original bridge was replaced in 1956 with a slightly higher, fixed span. This bridge eventually closed in 1997 but reopened to pedestrian and bicycle traffic in December 1999 as the Friendship Trail Bridge. This too was closed due to deterioration in late 2008. A parallel span was built in the mid-1970s and remains the current Gandy Bridge today. (Historic image courtesy Adele Gilmore.)

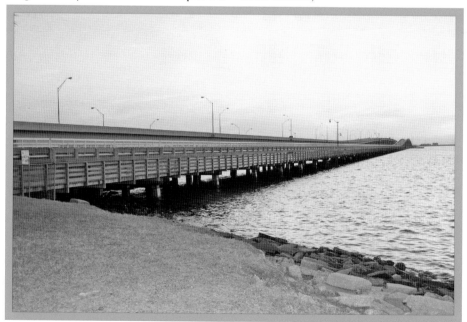

HELLO CITY: STREETS, PARKS, AND NEIGHBORHOODS

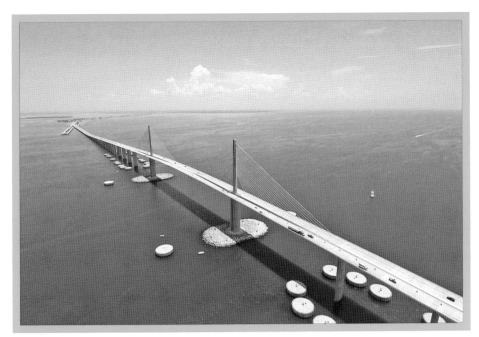

The first bridge span of the Sunshine Skyway opened in 1954. It stretched 15 miles long from St. Petersburg to Bradenton and rose 150 feet out of the water. A parallel span was completed in 1971. On May 9, 1980, thirty-five people met their death in what is known as one of the worst bridge disasters in history when the empty phosphate freighter *Summit Venture* slammed into the No. 2 south pier. The new cable-stay Sunshine Skyway Bridge opened in April 1987. (Both images courtesy City of St. Petersburg.)

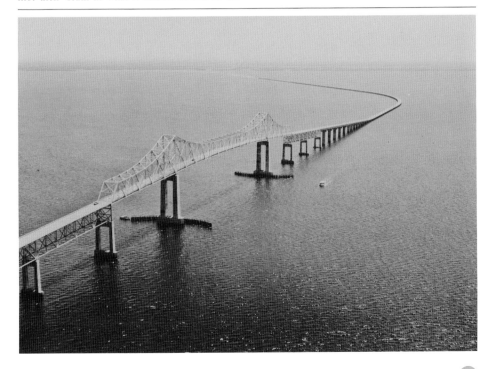

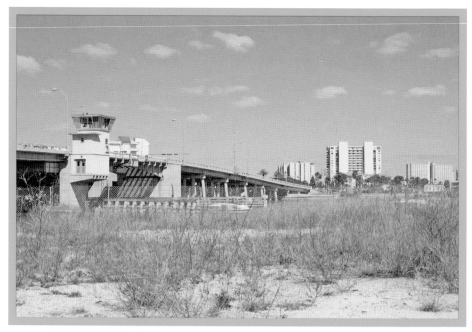

The Corey Avenue business district was first conceived in 1936. At that time, the area between the present site of the Beach Theatre and the end of the Corey Causeway was mangrove swamp. Eventually, the Upton Company saw the great potential of this attractive area. They bought the lots fronting Corey Avenue, filled the swamp, and paved the street. The Corey Causeway connects St. Pete Beach with the mainland of the city of South Pasadena. (Historic image courtesy Florida State Archives.)

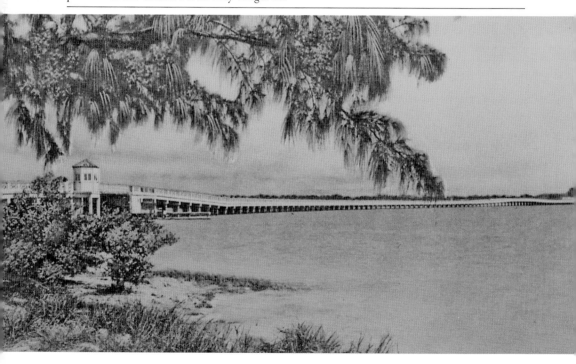

HELLO CITY: STREETS, PARKS, AND NEIGHBORHOODS

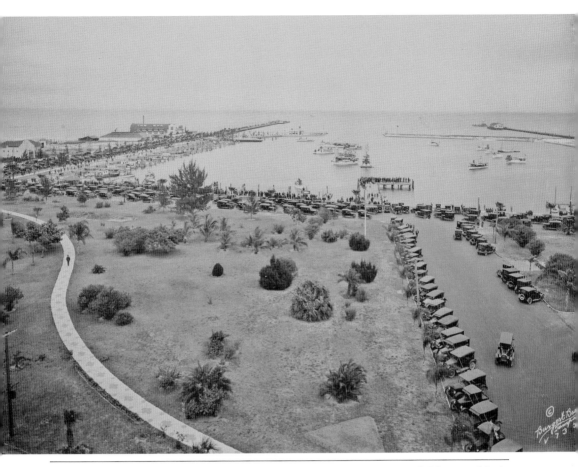

William L. Straub Park, shown here in 1934, is named in honor of the *St. Petersburg Times* editor who saved 30 blocks by the bay and created a riviera-style waterfront. Today the park bustles with activity and is surrounded by several high-rise condos, restaurants, and storefronts. (Historic image courtesy Tampa–Hillsborough County Public Library System.)

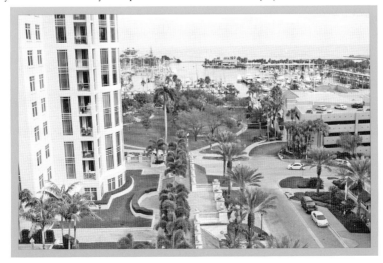

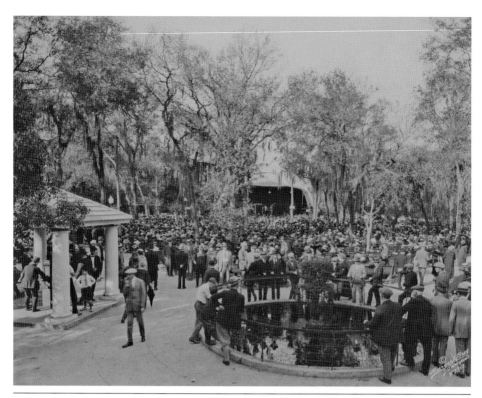

Encompassing an entire city block between Fourth and Third Streets North, and Second and First Avenues North, Williams Park, pictured above in 1925, is St. Petersburg's first park. Founded in 1888, it was originally named City Park. It was later changed to Williams Park in honor of John Constantine Williams, one of the founding fathers of St. Petersburg. (Historic image courtesy Tampa–Hillsborough County Public Library System.)

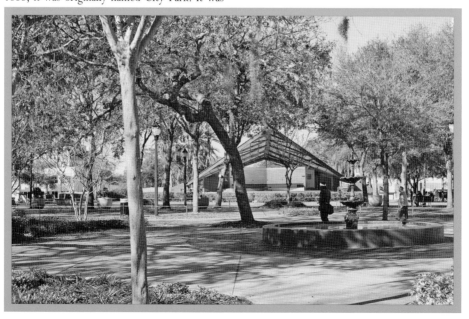

HELLO CITY: STREETS, PARKS, AND NEIGHBORHOODS

Below, this postcard of the Historic Roser Park Neighborhood is postmarked 1926, but Charles Martin Roser began work on the subdivision in 1911. It was the first residential subdivision to be established outside the city and was known as an early streetcar suburb, conveniently located along the downtown trolley line. Many original characteristics of this district remain, including the hexagon sidewalk pavers, granite curbstones, brick streets, and rusticated retaining walls. (Historic image courtesy Adele Gilmore.)

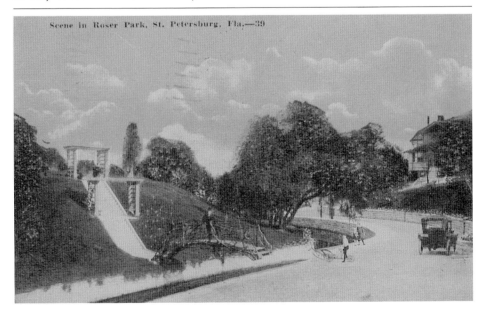

Scene in Roser Park, St. Petersburg, Fla.—39

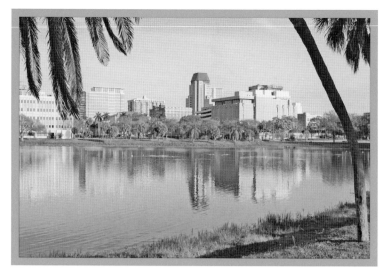

This 1967 postcard below portrays Mirror Lake, part of the historical Mirror Lake District in St. Petersburg. Some of St. Petersburg's most familiar sites border Mirror Lake, such as the Lyceum, the Coliseum, the famous lawn bowling and shuffleboard courts, and the old St. Petersburg High School. Locals still use Mirror Lake daily to walk, enjoy nature, or relax with friends. (Historic image courtesy Adele Gilmore.)

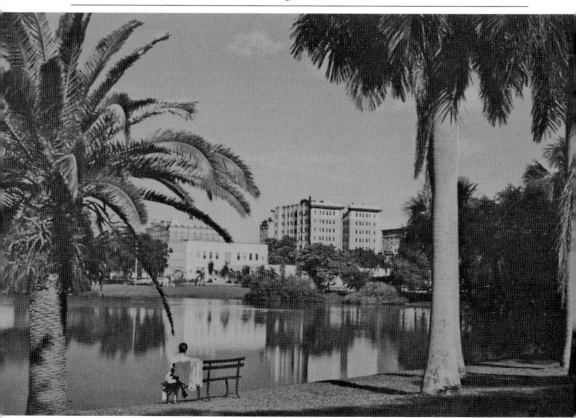

HELLO CITY: STREETS, PARKS, AND NEIGHBORHOODS

This postcard of Grove Hall in the 1970s shows a house located at 715 Seventh Avenue North. The card boasts newly furnished efficiency apartments close to Mirror Lake, the shuffleboard courts, and downtown. Not much has changed to this day; the apartments and the neighborhood itself still offer a quiet, shady atmosphere. (Historic image courtesy Adele Gilmore.)

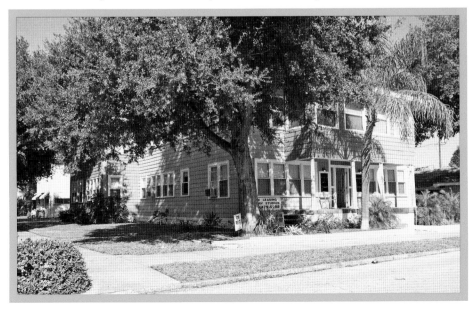

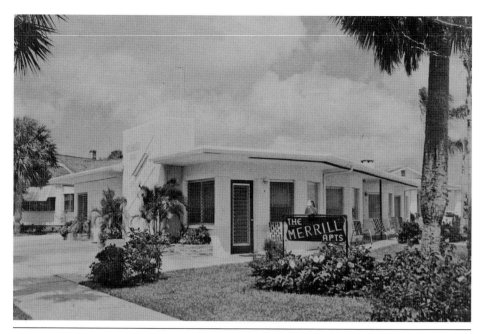

In 1973, George and Dorothea Peterka purchased the Merrill Apartments, located at 1101–1111 Beach Drive Northeast in St. Petersburg, for $116,000. The lot held 10 efficiency apartments. George's mother, Mary Peterka, lived in the largest apartment in the front. These dwellings were home to some of the St. Petersburg Cardinals, a winter league team then affiliated with the St. Louis Cardinals of Major League Baseball. (Historic image courtesy Ed and Karen Yarb.)

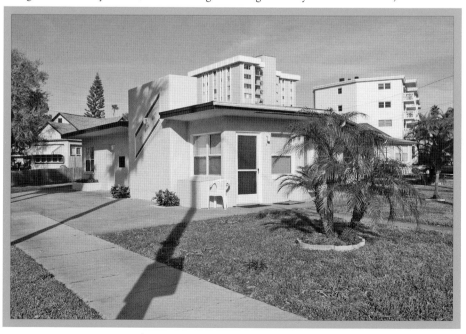

TOURIST TOWN

WHERE THE PEOPLE STAYED

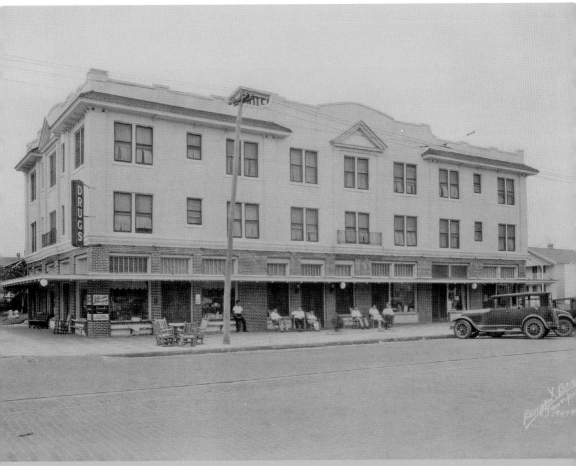

St. Petersburg was built on the tourism industry, dating all the way back to the 1920s. People wanted to visit paradise, and with the sunshine of St. Petersburg, they found something very close to heaven. The Wyoming Hotel, pictured here in 1926, was a three-story building with a drugstore and other stores on the main level. People could sit at tables placed along the sidewalk. (Courtesy Tampa–Hillsborough County Public Library System.)

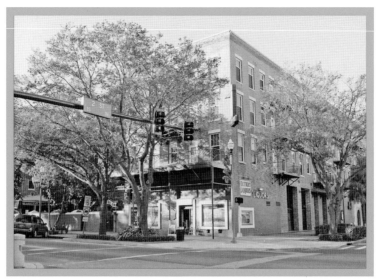

Local legend has it that around 1876 cofounders John C. Williams and Peter Demens flipped a coin to see who would have the honor of naming the city. Demens won the toss and named it after his birthplace, St. Petersburg, Russia. Williams, in turn, named the first hotel after his birthplace, Detroit, Michigan. The Detroit Hotel is alive and well, and has since been turned into condominiums. (Historic image courtesy Adele Gilmore.)

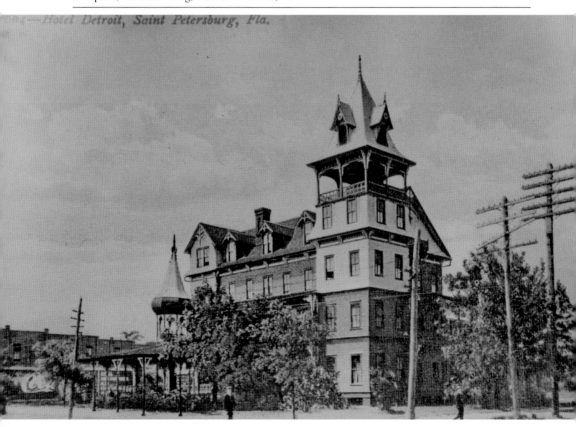

TOURIST TOWN: WHERE THE PEOPLE STAYED

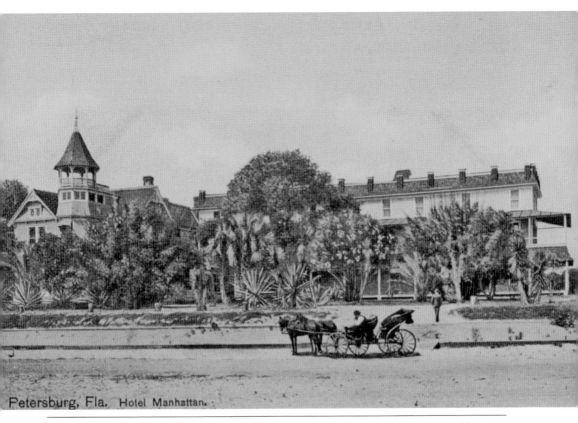

Petersburg, Fla. Hotel Manhattan.

Built in 1891, the Williams House was the home of Gen. John C. Williams, one of the cofounders of St. Petersburg. It is one of the earliest surviving buildings in St. Petersburg. In 1906, with additions, the building was converted into the Manhattan Hotel. It was originally located at 444 Fifth Avenue South, but the house was eventually moved to the University of South Florida, Bayboro campus, at 511 Second Street South. (Historic image courtesy Adele Gilmore.)

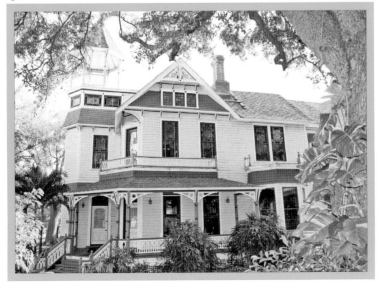

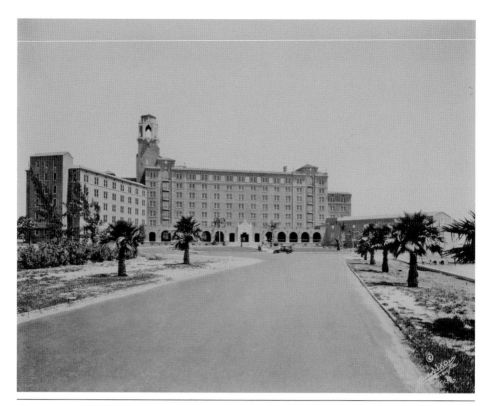

The Mediterranean Revival–style Vinoy Hotel opened in 1925 and is pictured above in 1926. In the early 1940s, the hotel was converted into a training facility for the U.S. Army Air Corps. With a $93-million restoration and a 1992 expansion, the hotel gained a guest tower and an 18-hole golf course. Also added were a private 74-slip marina, a 12-court tennis complex, five restaurants, and a 5,000-square-foot fitness center. (Historic image courtesy Tampa–Hillsborough County Public Library System.)

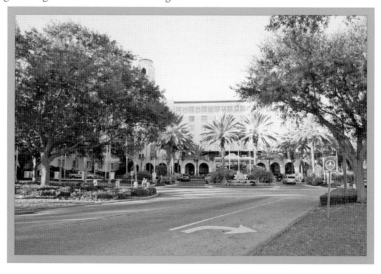

TOURIST TOWN: WHERE THE PEOPLE STAYED

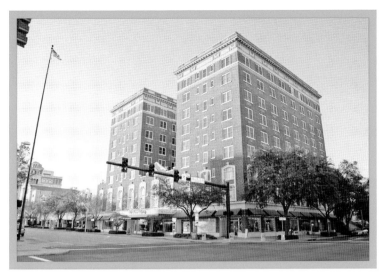

Significant for its Neoclassical Revival architecture, the Princess Martha Hotel was constructed in 1924 and added about 2,000 rooms to the area during the Florida land boom era to house the large number of tourists coming to the "Sunshine City." Shown below in 1926, it was the first hotel in St. Petersburg to be financed through the sale of public stock. Today the Princess Martha serves as one- and two-bedroom luxury apartment suites for active adults aged 55 and older. (Historic image courtesy Tampa–Hillsborough County Public Library System.)

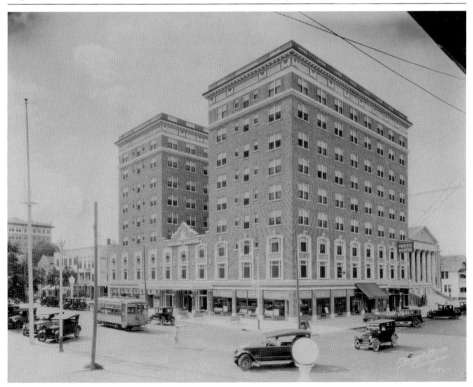

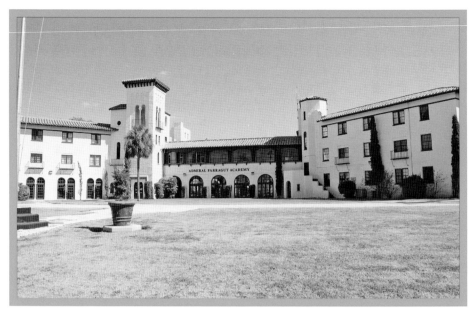

The Jungle Country Club was erected in 1925 and housed many wealthy Northern tourists until the beginning of World War II. During the war, the hotel was leased out to the U.S. Army Air Corps. In 1945, the Jungle Country Club Hotel and the adjoining golf course were sold to the Admiral Farragut Academy, a military preparatory school, and they have remained in the school's possession ever since. (Historic image courtesy Tampa–Hillsborough County Public Library System.)

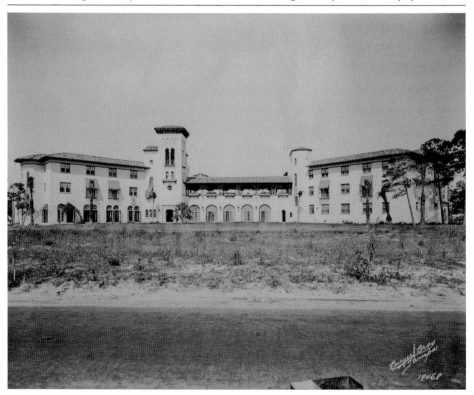

TOURIST TOWN: WHERE THE PEOPLE STAYED

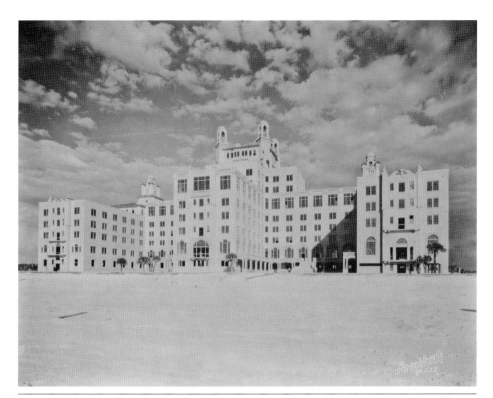

The Don CeSar Beach Resort, known as "Florida's Legendary Pink Palace," was built in 1928 to resemble the Royal Hawaiian in Waikiki Beach for $1.2 million. High society could be found at the hotel, with the likes of F. Scott Fitzgerald, Clarence Darrow, Lou Gehrig, and Al Capone making frequent visits. In 1942, the U.S. Army purchased the property and turned it into a convalescent center for battle-fatigued World War II airmen. Multimillion-dollar renovations were made to the hotel in 1994. (Historic image courtesy Tampa–Hillsborough County Public Library System.)

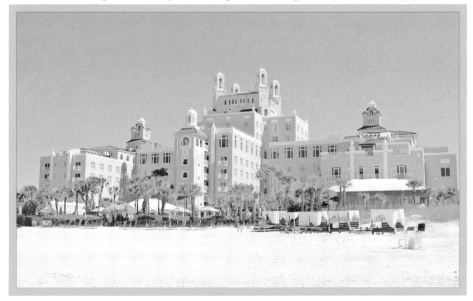

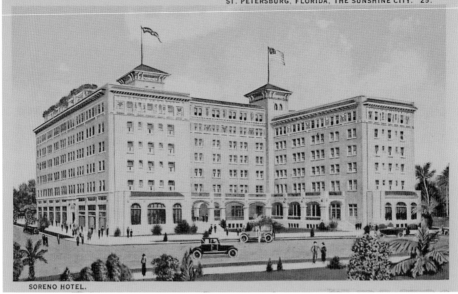

SORENO HOTEL.

In 1923, construction began on Soren Lund's "Million Dollar" Mediterranean Revival hotel. The Soreno Hotel was the first million-dollar hotel in the city and was named after Lund's only son. It encompassed the north half of the 100 block of Beach Drive. During World War II, the Soreno Hotel was occupied by servicemen. Its demolition, which took place in 1992, is shown in the end credits of *Lethal Weapon 3*. Today the Florida condo tower stands in the Soreno's place. (Historic image courtesy of Adele Gilmore.)

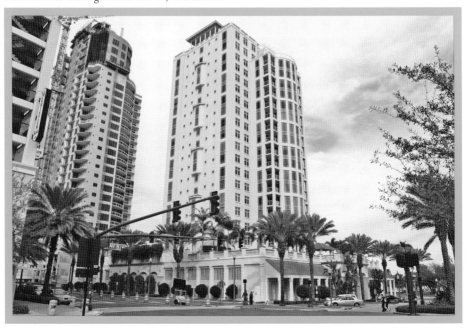

TOURIST TOWN: WHERE THE PEOPLE STAYED

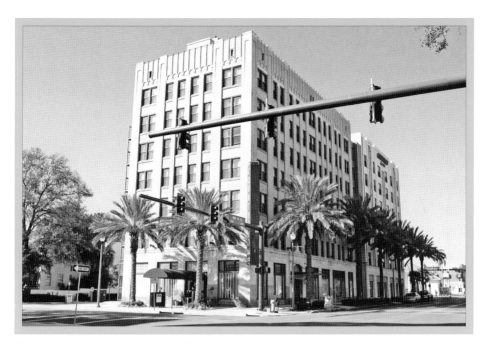

The Pennsylvania Hotel, built for $325,000 by Harry C. Case in 1925 during the city's golden era of hotels, reflected the changing character of the city's hospitality industry as larger hotels were built during the Florida land boom era. The Pennsylvania Hotel is significant for its architectural association with the Chicago style, a rare building style in St. Petersburg that blended art deco and classical influences. The Marriott Hotel chain currently owns the hotel. (Historic image courtesy the author.)

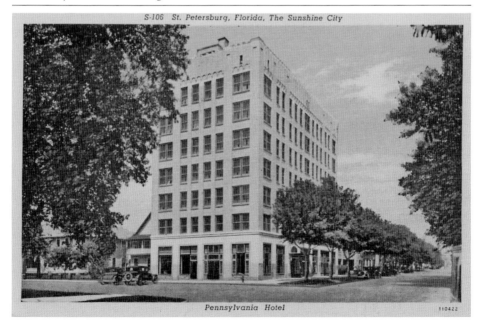

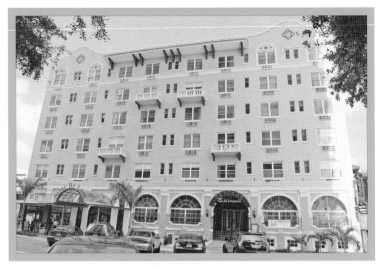

Often coined the "Downtown Gem" by locals, the 85-room Hotel Ponce De Leon was constructed in 1922. This European-style hotel played host to many artists, musicians, and international travelers, as well as politicians such as U.S. president Richard Nixon. The original Otis elevator still dwells within its walls. Now the Ponce De Leon also has a coffee shop, the Ten Beach Drive Flamenco Bar, and the Spanish restaurant Ceviche. (Historic image courtesy Tampa–Hillsborough County Public Library.)

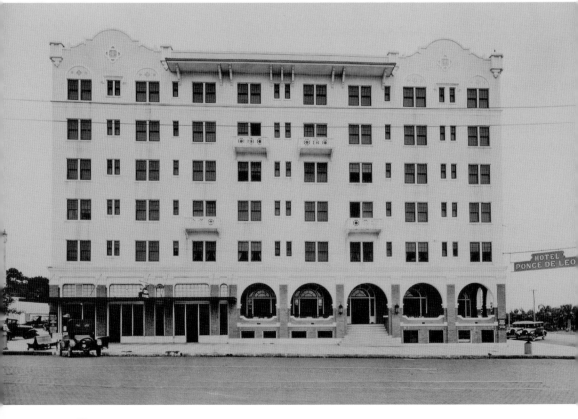

TOURIST TOWN: WHERE THE PEOPLE STAYED

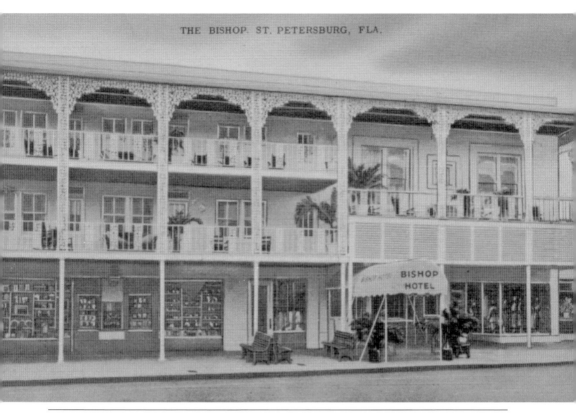

The Bishop Hotel was built in 1912 and was owned by Roy Bishop, a Sinclair Oil Company distributor from St. Petersburg. Through the years, the Bishop Tavern, a neighborhood bar on the first floor, has remained open and is located at 260 First Avenue North. As recently as 2007, new ownership put $150,000 into renovations, giving the bar a polished, New Orleans party bar image. It caters to a young professional crowd with drink specials and either live music or DJs spinning music. (Historic image courtesy the author.)

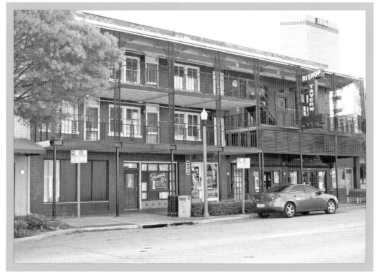

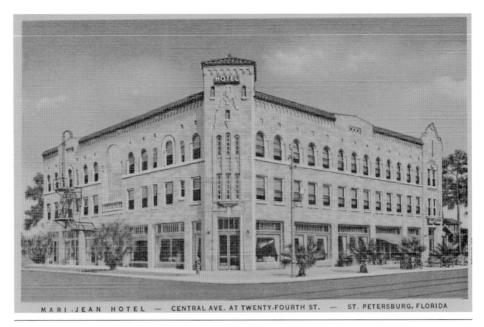

MARI-JEAN HOTEL — CENTRAL AVE. AT TWENTY-FOURTH ST. — ST. PETERSBURG, FLORIDA

The 1926 Mari-Jean Hotel, like many St. Petersburg hotels, was built during the land boom of the 1920s. But unlike most of those hotels, the Mari-Jean would be operated by its owners for more than 34 years, until 1960. The hotel opened seasonally, and lodging was extended-stay, meaning guests would stay the duration of the tourist season without moving. Currently, the building is operated as the Mari-Jean Adult Care Center. (Historic image courtesy the author.)

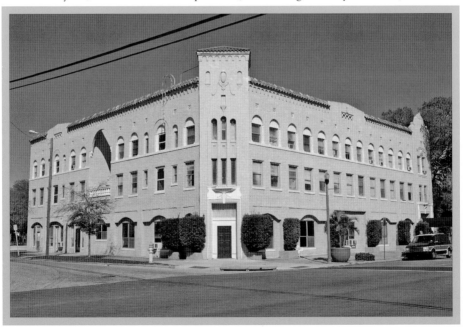

TOURIST TOWN: WHERE THE PEOPLE STAYED

The Wigwam Hotel's claim to fame was that it was once home to Tony Jannus, the first pilot to fly an airboat from St. Petersburg to Tampa in 1914. Eventually, he flew this route twice daily. At the Wigwam Hotel, a visitor could get a room with meals included for $12 a day, which at the time was considered expensive. Now the backside of Bay Walk sits on the land where the Wigwam once played host to its guests, on the corner of First Street North and Third Avenue. (Historic image courtesy Adele Gilmore.)

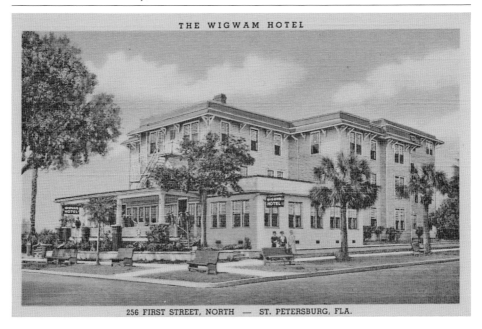

THE WIGWAM HOTEL

256 FIRST STREET, NORTH — ST. PETERSBURG, FLA.

The Hotel Scott, pictured below in 1922, opened its doors in 1921 and two years later was sold to the Cordova family. The Hotel Cordova reigned from 1923 to 1999, and although the Cordovas sold it in the 1950s, the name remained the same. There are rumors that the hotel is still haunted by a man who provided 20 years of concierge service there. After a complete renovation in 2000, it became the Pier Hotel. (Historic image courtesy Tampa–Hillsborough County Public Library System.)

Tourist Town: Where the People Stayed

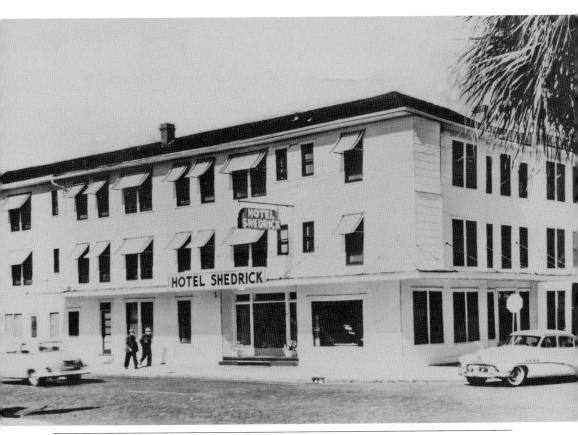

Hotel Shedrick, at 701 Fifth Avenue North, was conveniently located in the Mirror Lake District. The back of the postcard brags about its accessibility to the shuffleboard courts. The Hotel Shedrick was eventually torn down, and in 1992, the Alpha House of Pinellas County, a center that helps young pregnant women, was built at this address. (Historical image courtesy Adele Gilmore.)

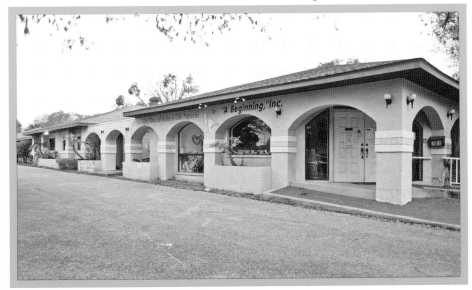

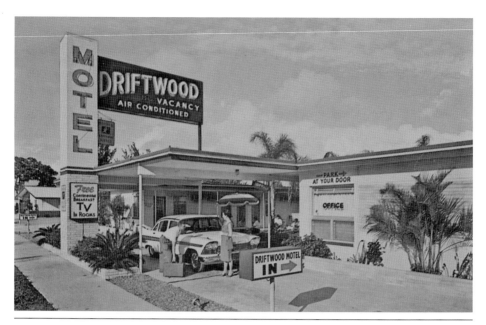

The Driftwood Motel was the perfect getaway for tourists like these, shown above in the 1970s. Located at 1600 Thirty-fourth Street South, the Driftwood is close to the Sunshine Skyway Bridge, the beach, and several restaurants. Its simple characteristics resemble many of the hotels built around the same time period along Thirty-fourth Street. It is one of few that remain open today. (Historic image courtesy Adele Gilmore.)

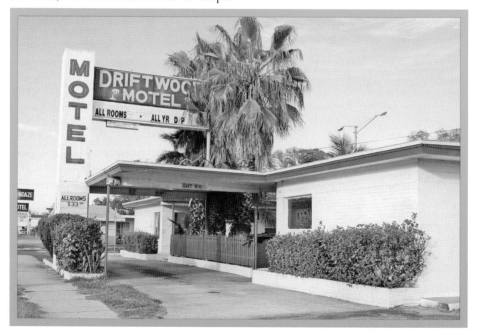

TAKING CARE OF BUSINESS

LOCAL COMMERCE

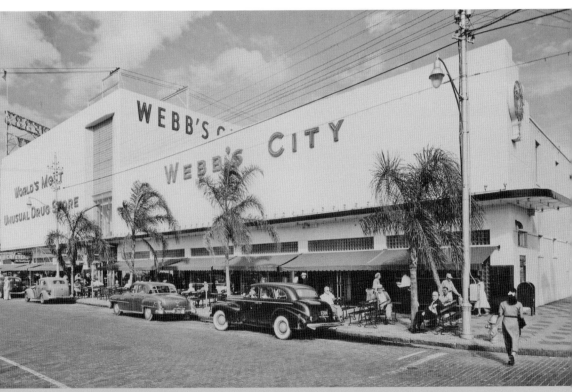

In 1925, patent-medicine man James Earl "Doc" Webb bought into a small drugstore in St. Petersburg. The store eventually spanned seven blocks and sold drugs, hardware, haircuts, plants, and clothing. An Arthur Murray Studio taught dance on the roof. At its height, Webb's City employed more than 1,200 people and served an average of 60,000 customers a day. After a great economic decline in St. Petersburg, the store fell into bankruptcy in 1979, and the "World's Most Unusual Drug Store" closed its doors forever. (Courtesy Tampa–Hillsborough County Public Library System.)

43

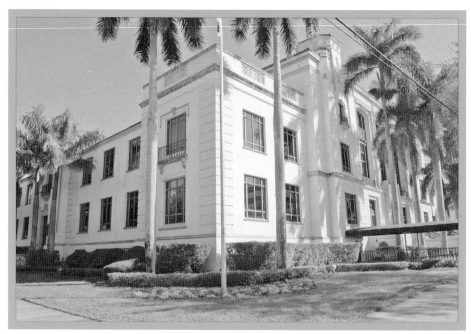

After the real estate market crashed during the Great Depression of the 1920s, St. Petersburg was able to bounce back with large public works administration projects in the 1930s. An economic recovery began with $10 million in new investments, and in 1939, St. Petersburg City Hall was built with New Deal federal funds. City hall still stands today and is an example of St. Petersburg's economic triumph during pressing times. (Historic image courtesy the author.)

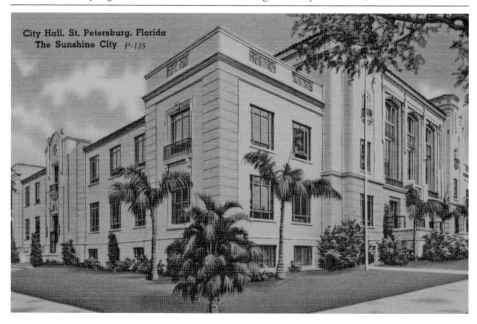

City Hall, St. Petersburg, Florida
The Sunshine City P-135

The historic Open Air Post Office has served St. Petersburg since it was dedicated in 1916. Postmaster Roy Hanna envisioned a street-level post office without steps, open on all sides to allow patrons easy access to their boxes at any hour. In 1969, the south wall and one-third of the east wall were enclosed to allow for indoor service counters, air-conditioning and heating, and additional postal boxes. It was placed on the National Register of Historic Places in 1975. (Historic image courtesy Heritage Village Archives and Library.)

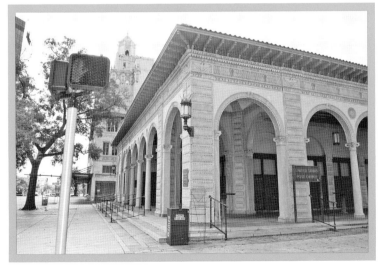

By the 1920s, a black community known as Cooper's Quarters had expanded and was known as the "gas plant area." The name came from the two tall tanks that stored the natural gas supply for the city. Cooper's Quarters was located a couple of blocks north and west on Ninth Street South at Second Avenue. Tropicana Field, home of Major League Baseball's Tampa Bay Rays, is just east of Cooper's Quarters today. (Historic image courtesy St. Petersburg Museum of History.)

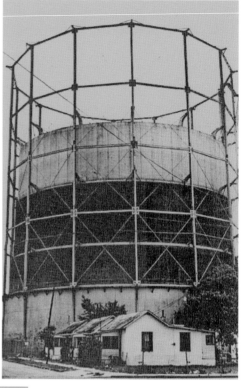

TAKING CARE OF BUSINESS: LOCAL COMMERCE

Looking west from Central Avenue along Third Street, the Florida Federal Savings building, with its unusual facade, is shown below in the 1970s. The artwork was created by Harrison Covington in 1974. It was a gift from Florida Federal to the people of Florida and pays homage to the Timucuan Indians. Today this structure is known as the Municipal Services Parking Facility. (Historic image courtesy Florida State Archives.)

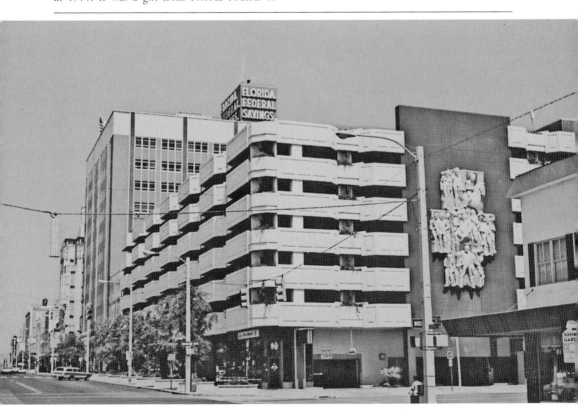

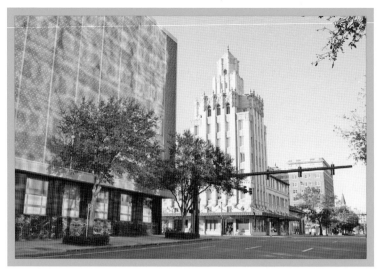

The First National Bank, the Snell Arcade— also known as the Rutland Building—and the Princess Martha have graced Fourth Street North for decades. The Snell Arcade and the Princess Martha, both products of the 1920s, are listed on the National Register of Historic Places. (Historic image courtesy Florida State Archives.)

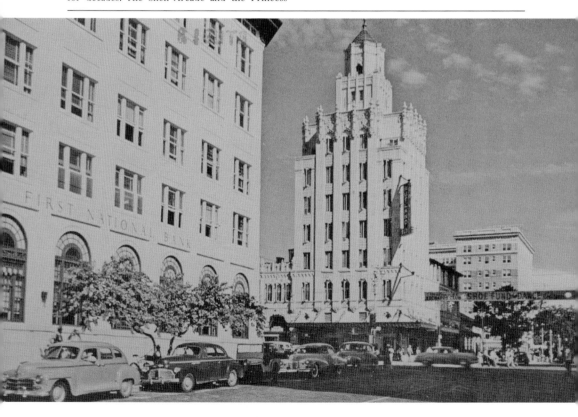

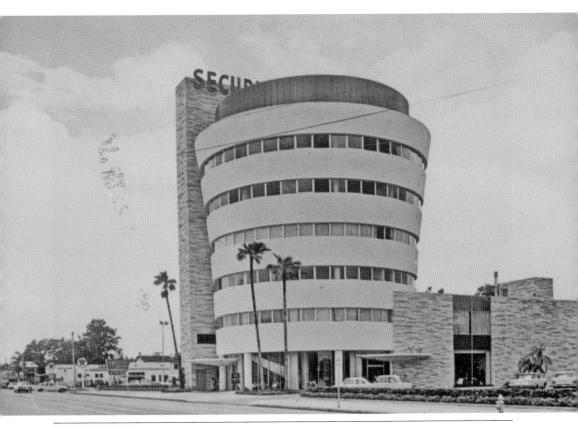

When this structure was built in the 1950s, it was known as the Security Federal Savings and Loan building. The building itself has always been controversial because of its height for a building built so far north (most buildings were not this tall), located at Ninth Street and Twenty-sixth Avenue North, and for its design, which was highly influenced by Frank Lloyd Wright's Guggenheim in New York. At one point in its existence, there was even a restaurant at the top. Grow Financial currently occupies this structure today. (Historic image courtesy Florida State Archives.)

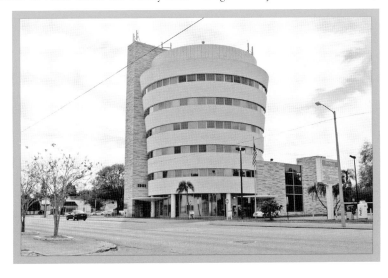

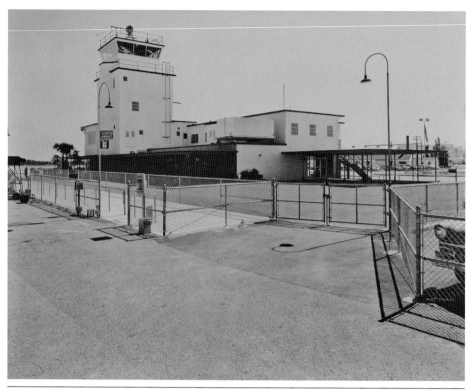

On January 1, 1914, a small flying boat took off near what is now Albert Whitted Airport. Today this airport is recognized as the birthplace of scheduled airline flight. National Airlines, one of the nation's first airlines, began service here in 1934. In the late 1930s, Albert Whitted was one of the first airports Goodyear chose to use as a base for its blimps. During World War II, hundreds of naval cadets received training here, and about 80,000 flight operations still take place each year at this airport. (Historic image courtesy Tampa–Hillsborough County Public Library System.)

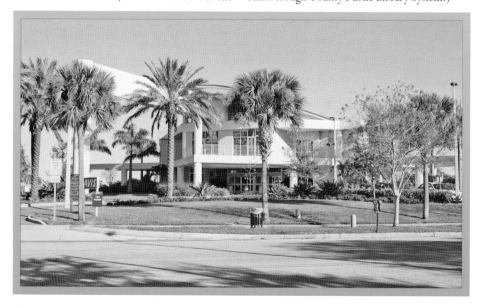

TAKING CARE OF BUSINESS: LOCAL COMMERCE

WSUN had its inaugural broadcast on November 1, 1927, when it began sharing time with WFLA. The WSUN studios, pictured below around 1927, were on the second floor of the Municipal Pier Casino. The original WSUN transmitter is now a permanent exhibit in the Smithsonian Institute in Washington. Today, as part of Cox Radio, WSUN broadcasts alternative rock music on 97.1 FM from studios in St. Petersburg. (Historic image courtesy St. Petersburg Museum of History.)

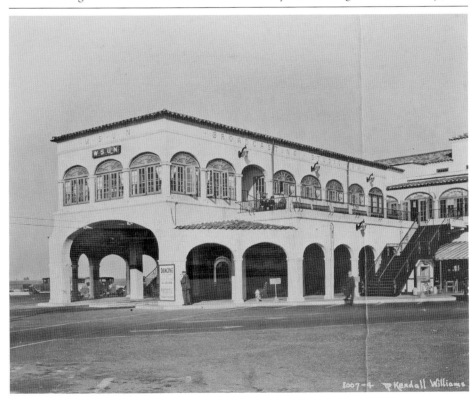

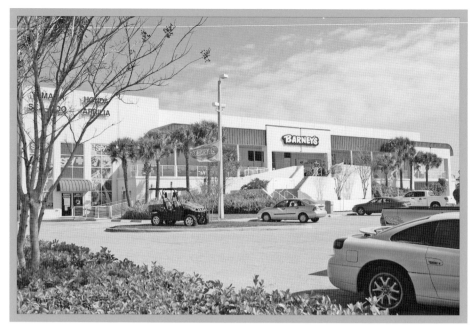

In 1951, a family-owned business named Barney's relocated to Gandy Boulevard in St. Petersburg from Bloomington, Illinois. When first established, Barney's had few employees. Today the shop employs more than 100 people, has purchased four adjoining sites, and has added locations in Brooksville and Brandon, Florida. In 2002, Barney's built a new modern showroom, complete with a museum preserving its past. (Historic image courtesy Florida State Archives.)

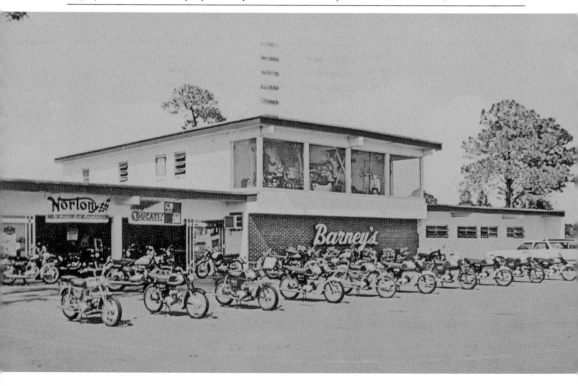

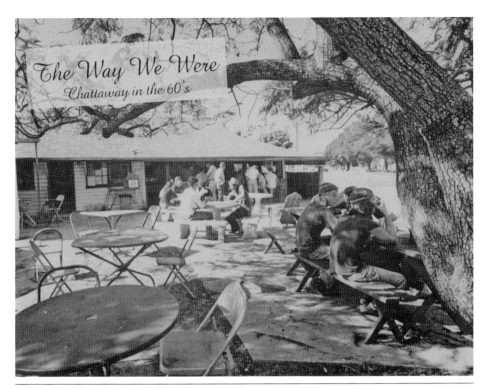

In 1922, the Four Corners Grocery was built at Twenty-second Avenue and Fourth Street South. The store sold soda pop, candy, and cigarettes. In 1933, its name was changed to the Chattaway Drive-In, and when Prohibition was repealed, beer and wine were also sold. By the 1940s, the Chattaway had burgers on the menu, and after changing ownership several times, Helen Lund became the owner in 1951. Helen's son Everette and his wife, Jill, soon joined the family business. Since Everette's passing, Jill has retained ownership. (Historic image courtesy Jill Frers.)

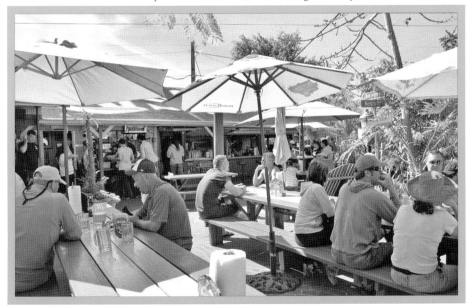

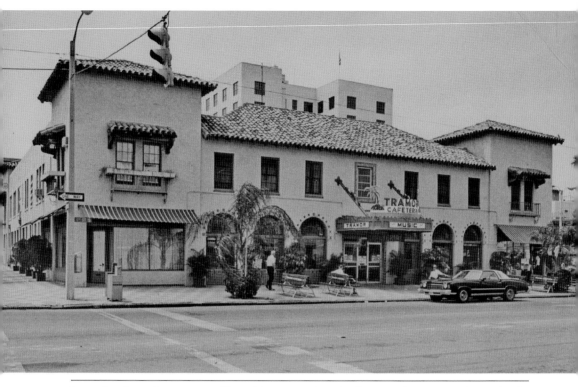

Located on the southwest corner of Second Avenue and Fourth Street South in downtown St. Petersburg, the historic Tramor Cafeteria has been feeding people since before World War II. The inside of the Tramor is highlighted by a blue ceiling painted with white clouds to simulate a sunny day in Florida. The cafeteria is now owned by the *St. Petersburg Times*, which uses it as an employee cafeteria. (Historic image courtesy St. Petersburg Museum of History.)

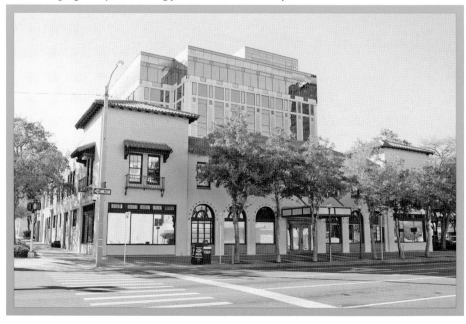

TAKING CARE OF BUSINESS: LOCAL COMMERCE

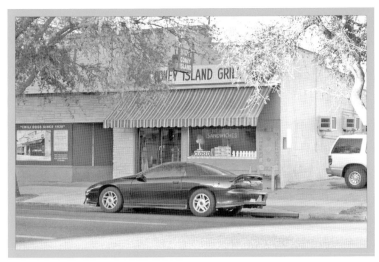

When Coney Island Grill first opened its doors in 1926, hotdogs were 5¢, and hamburgers were 10¢. The restaurant moved to the location pictured below in 1950, and the old spot, which was next door, was turned into a parking lot. Hank Barlas, the son of the original owner, still owns the Coney Island Grill, and aside from the addition of air-conditioning, the restaurant has not changed, except, of course, for the prices. (Historic image courtesy Hank Barlas.)

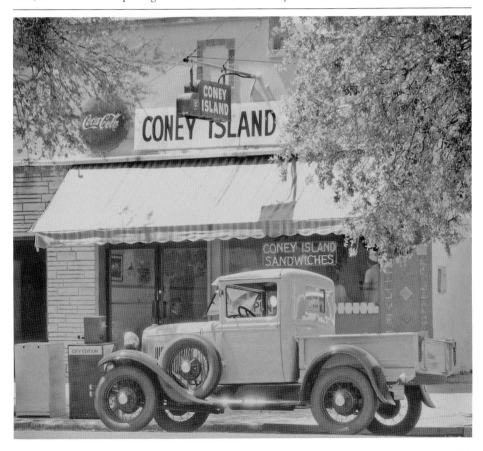

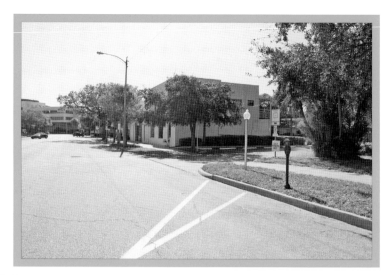

Established in 1939 by Ed and Hattie Boore, Aunt Hattie's evolved into a local landmark known for good home-cooked meals and unusual promotions. One such promotion involved trading 10,000 oranges for 10,000 pounds of snow. In the 1940s and 1950s, the building underwent numerous renovations. But a combination of pesky rodents, financial troubles, and a hurricane ultimately lead to the demise of Aunt Hattie's. In 1985, it closed, its property was donated to the University of South Florida, and it was leveled by 1988. (Historic image courtesy Adele Gilmore.)

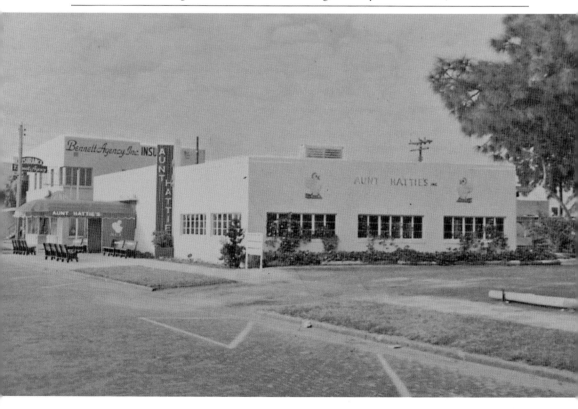

TAKING CARE OF BUSINESS: LOCAL COMMERCE

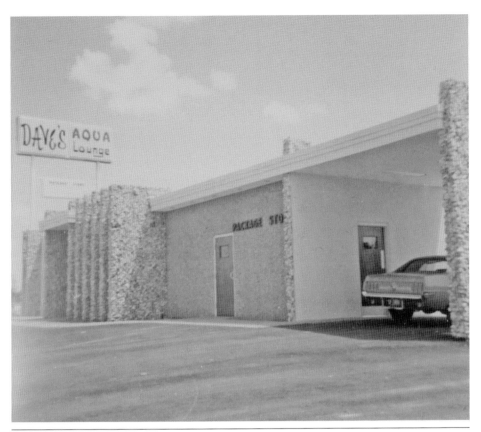

In 1964, Dave Mamber Sr. opened a bar on Gandy Boulevard called the Aqua Bar. In 1969, a new structure was built next door, the current location for Dave's Aqua Lounge run by his son Dave Mamber Jr. Weird shadows, women's voices, and an old barmaid are said to be a few of the spirits haunting Dave's. If the walls could talk, they would speak about late-night rendezvous, great live performers, and an old patron whose nickname was "Larry the Groper." (Historic image courtesy Dave Mamber Jr.)

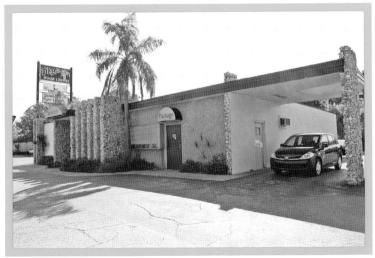

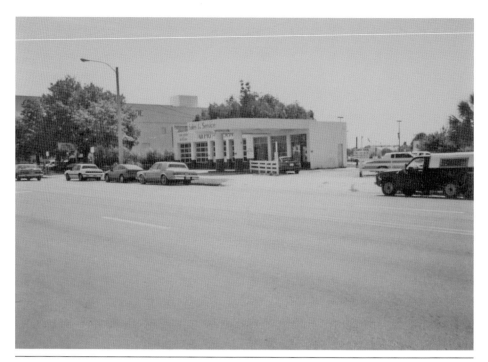

In 1991, Mark Ferguson bought an old Sunoco gas station in the hopes that one day St. Petersburg would acquire a major-league franchise. Early on, his bar, Ferg's, sponsored local softball, flag football, and basketball, until Tropicana Field was built and became home to professional hockey and arena football. In 1995, St. Petersburg and Ferg's got their baseball team with the Tampa Bay Rays. Ferg's has been a favorite sports bar ever since. (Historic image courtesy of Mark and Sherry Ferguson.)

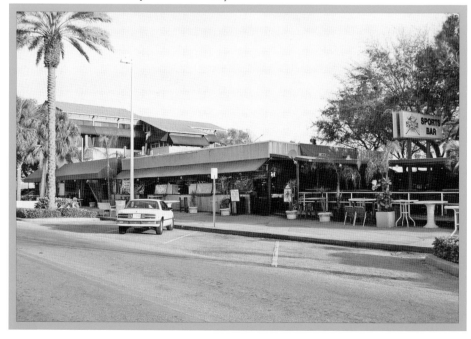

MIND, BODY, AND SPIRIT

FACILITIES SHAPING A COMMUNITY

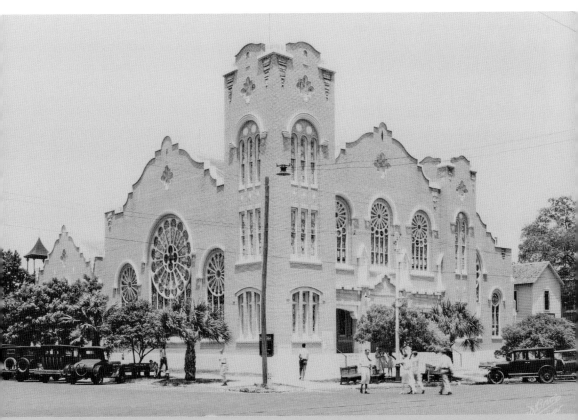

With plenty of activities to be found year-round, St. Petersburg forged ahead with growth and progress. The schools, hospitals, and churches played important roles in helping the community on many different levels. The First Avenue Methodist Episcopal Church is shown here in 1926. It is located at 467 First Avenue North. (Courtesy Tampa–Hillsborough County Public Library System.)

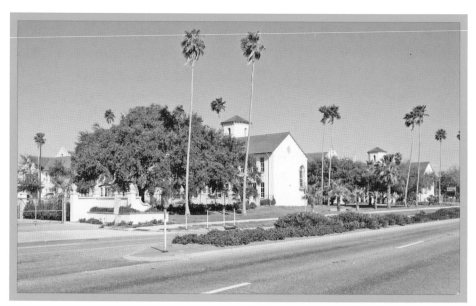

When St. Petersburg High School was built in 1926, it was dubbed the nation's first "Million Dollar High School." This Mediterranean Revival–style building was designed by architect William B. Ittner and was listed on the National Register of Historic Places in 1984. The school previously occupied several other locations, including one at Mirror Lake. Current enrollment at St. Petersburg High School sits around 2,255 students. (Historic image courtesy Tampa–Hillsborough County Public Library System.)

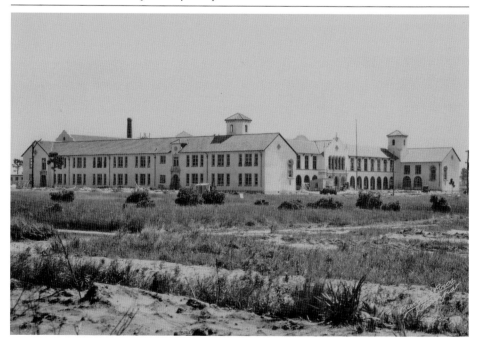

MIND, BODY, AND SPIRIT: FACILITIES SHAPING A COMMUNITY

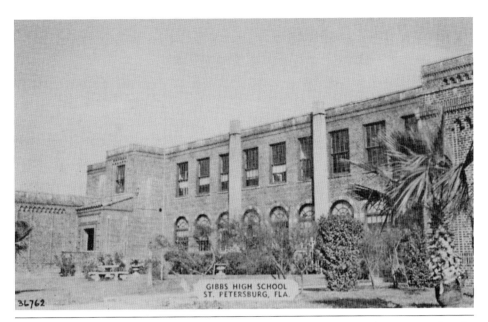

GIBBS HIGH SCHOOL
ST. PETERSBURG, FLA.

36762

Before 1927, St. Petersburg had no school for African American children that educated past sixth grade. Gibbs High School became the first public secondary school for blacks. The building had eight classrooms and cost $49,490 to build. Gibbs is currently the largest high school in St. Petersburg, with more than 2,500 students. It moved to the brand-new campus pictured below with state-of-the-art facilities for the 2005–2006 school year. (Historic image courtesy Heritage Village Archives and Library.)

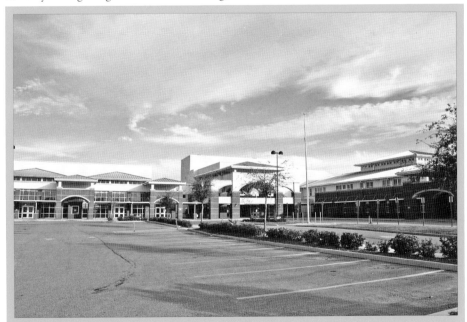

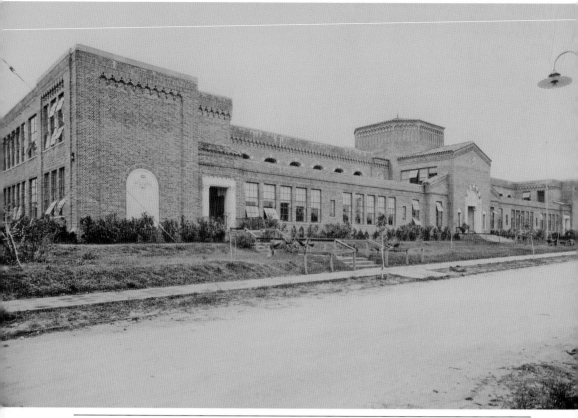

Designed in the 1920s by architect Henry Taylor, Southside Junior High School was one of the last schools built in St. Petersburg until 1950 due to a drop in enrollment because of the Great Depression. It remained a junior high school until 1972, when it closed for a year and reopened as Southside Alternative School. In 1980, the Pinellas Board of Public Instruction converted the building into a fundamental middle school. (Historic image courtesy Tampa–Hillsborough County Public Library System.)

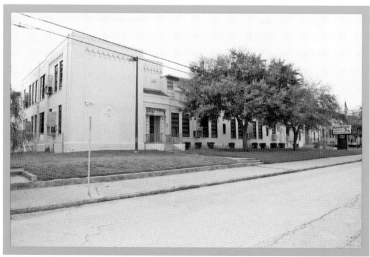

MIND, BODY, AND SPIRIT: FACILITIES SHAPING A COMMUNITY

The St. Petersburg Junior College was founded in 1927 as a private community college. Today it is a public institution and provides community college programs, much like it did when it first opened, but it has expanded and now offers four-year bachelor degrees in some areas. It has several campuses located throughout Pinellas County. In 2001, its name was changed to St. Petersburg College. The above photograph showcases the St. Petersburg College Downtown Center, which opened in 2005. (Historic image courtesy Florida State Archives.)

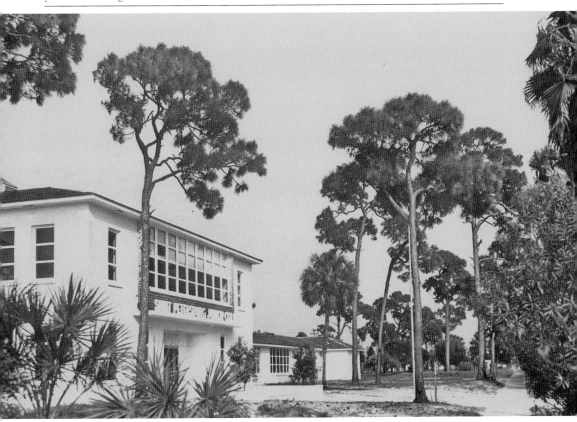

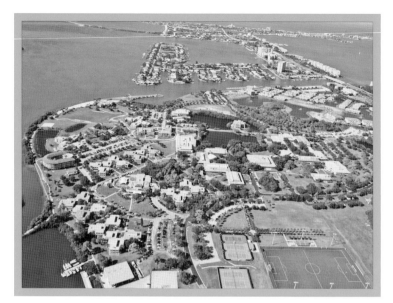

Founded in 1958 as Florida Presbyterian College, Eckerd College, pictured below in 1961, commenced its first classes in 1960 at the U.S. Maritime Service Training Station on Bayboro Harbor and moved to its current home on Boca Ciega Bay a few years later. More than 1,800 residential students from 47 states and 35 countries, and 1,000 adult learners from the Tampa Bay area seek bachelor's degrees from Eckerd, a featured school in Loren Pope's *Colleges That Change Lives*. (Historic image courtesy Eckerd College Archives and Library.

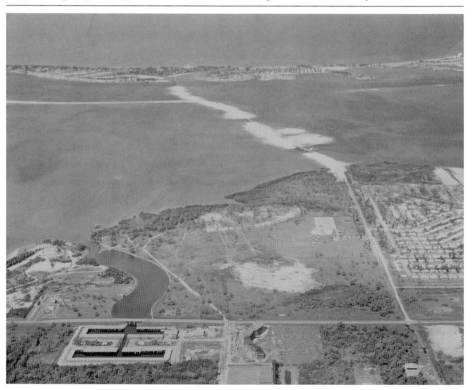

MIND, BODY, AND SPIRIT: FACILITIES SHAPING A COMMUNITY

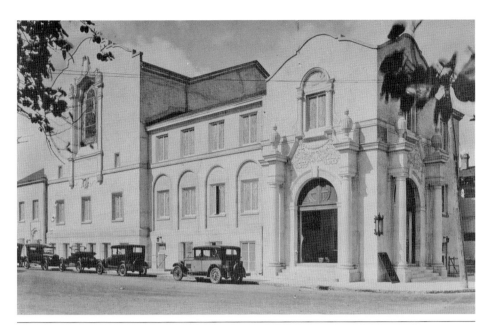

During the 1920s, the Lyceum appeared in St. Petersburg, providing audiences with literary and scientific knowledge sponsored by the leading churches. During the Great Depression, Lyceum programs continued but on a lesser scale and eventually became obsolete. Today social galas, private celebrations, weddings, receptions, and corporate functions take place in the Lyceum, which still has the original oak hardwood floors, among other timeless traits. (Historic image courtesy St. Petersburg Museum of History.)

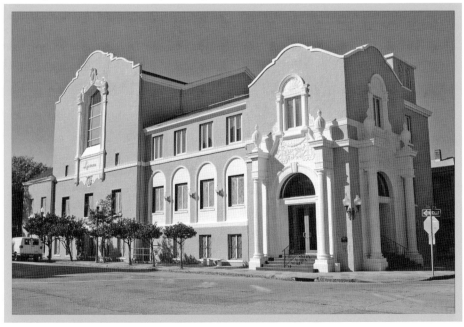

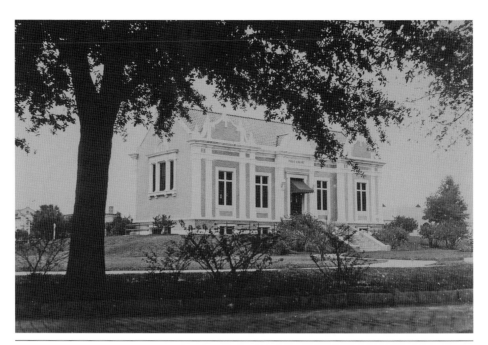

With the construction of the Carnegie Library in 1915 in Beaux-Arts style, the St. Petersburg Public Library System began. Andrew Carnegie and the Carnegie Corporation gave more than $56 million to build 1,697 public libraries in 1,412 American communities. Now known as the Mirror Lake Branch Library, it sits at the east end of the lake in Mirror Lake Park. On June 13, 1986, it was added to the National Register of Historical Places. (Historic image courtesy City of St. Petersburg.)

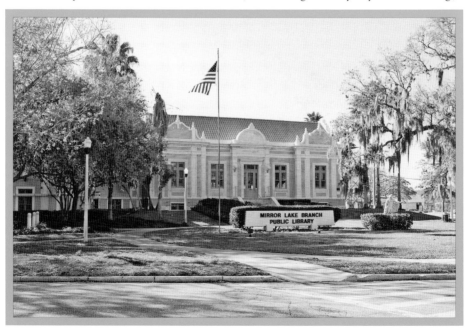

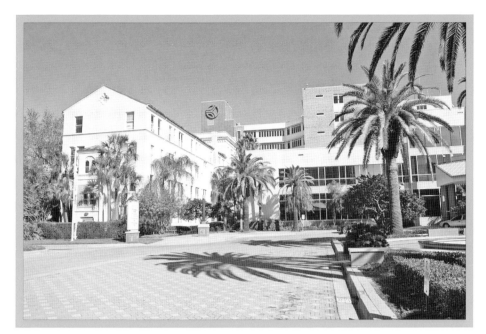

This long-standing medical complex was founded in 1906 as the St. Petersburg Sanitarium and changed its name to Good Samaritan Hospital in 1910. It was renamed as Augusta Memorial Hospital, pictured below next to an old Native American shell mound, in 1913. By 1918, it changed its name to City Hospital and again in 1923 to Mound Park Hospital. Finally, it was renamed Bayfront Medical Center, Inc., in 1968. (Historic image courtesy Heritage Village Archives and Library.)

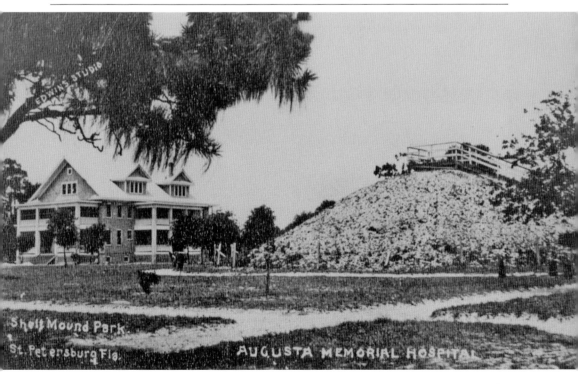

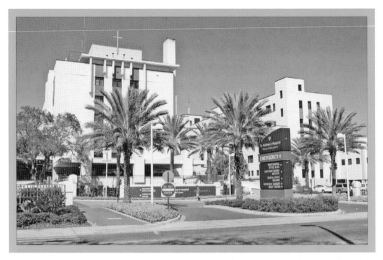

The postcard below is dated 1970, but St. Anthony's Hospital was founded in 1920 as the small, private Faith Hospital. It flourished up until the Great Depression, and in 1931, it was bought by the Franciscan Sisters of Allegany, New York, for $40,000. They reopened its doors as St. Anthony's Hospital. Even though many could still not afford medical services, they still received the care they needed. Today there are more than 1,400 employees and nearly 500 physicians on staff. (Historic image courtesy the author.)

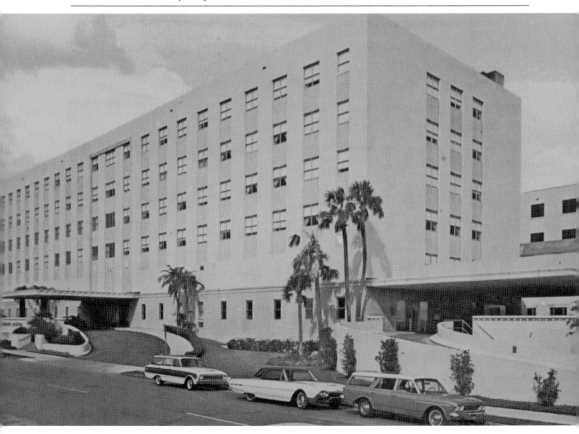

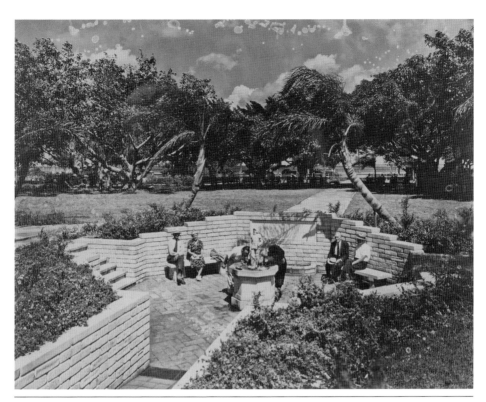

A major tourist attraction in its day, the Fountain of Youth was drilled at the beginning of the 20th century by one of the city's founders, E. H. Tomlinson. Spanish explorer Ponce De Leon marketed the well's sulfur water for its supposed health benefits. Some reports claimed the water had three times more lithium than any spring in Florida. In 1975, the fountain was shut down for repairs. It never reopened. (Historic image courtesy Tampa–Hillsborough County Public Library System.)

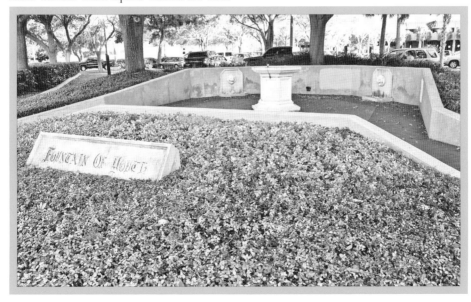

The First Methodist Church was established in 1887 and built around 1925. During construction, part of it collapsed. This Gothic Revival church has 10 Tiffany-style stained glass windows depicting the life of Christ and is listed on the National Register of Historic Places. The church's lofty bell tower originally housed a 10-bell carillon and has since been increased to 15 bells. The largest bell weighs 2,208 pounds. (Historic image courtesy Tampa–Hillsborough County Public Library System.)

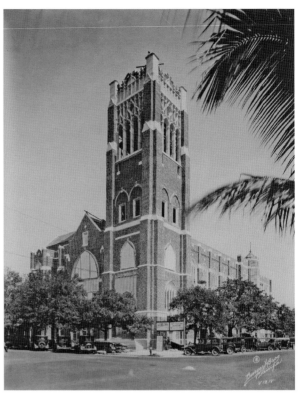

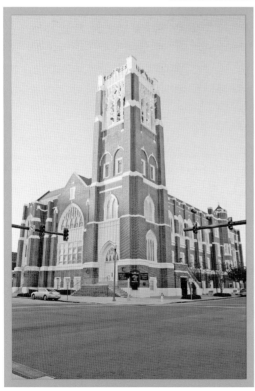

MIND, BODY, AND SPIRIT: FACILITIES SHAPING A COMMUNITY

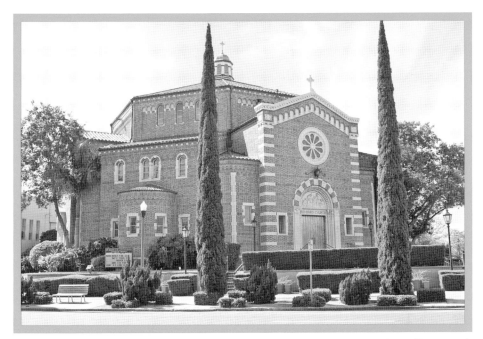

Built in 1929 at the cost of $129,000, the St. Mary Our Lady of Grace Church stands at the southwest corner of Fourth Street South and Fifth Avenue South. The land was purchased in 1928 from the owners of the former estate, which had belonged to founding father Gen. John Williams. Built during the hard times of the Great Depression, it underwent major renovations in 1955, 1968, and 1995. (Historical image courtesy Florida State Archives.)

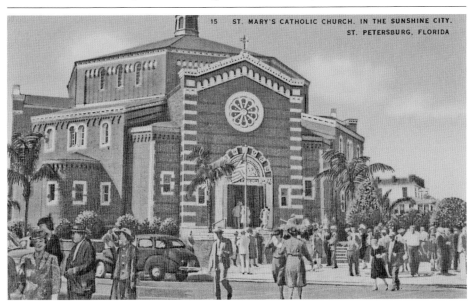

15 ST. MARY'S CATHOLIC CHURCH, IN THE SUNSHINE CITY.
ST. PETERSBURG, FLORIDA

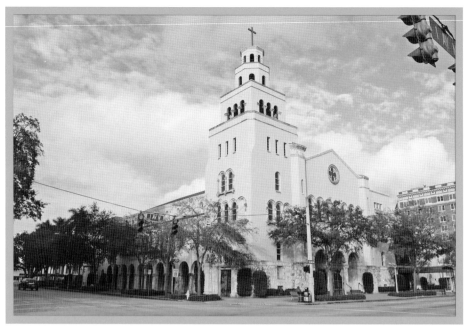

The Christ Methodist Church is located at 467 First Avenue North and is now known as the Christ United Methodist Church. It is a local icon and has remained in downtown St. Petersburg for more than 100 years. Today the church offers youth, adult, family, and music ministries to the St. Petersburg community. (Historic image courtesy Adele Gilmore.)

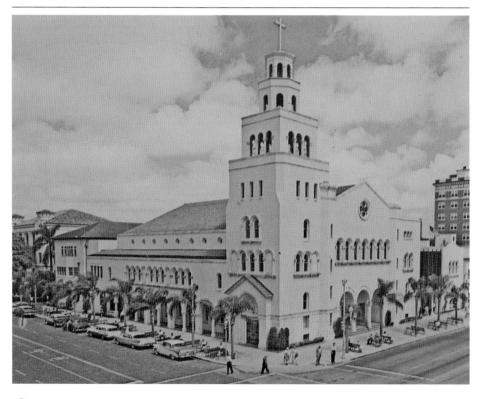

MIND, BODY, AND SPIRIT: FACILITIES SHAPING A COMMUNITY

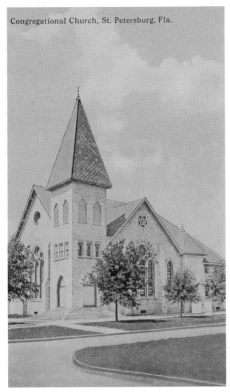

Congregational Church, St. Petersburg, Fla.

Built in 1912, the United Church of Christ, also known as the First Congregational Church, is a great example of Gothic Revival architecture. During the 1920s, the church held a popular Lyceum series, which was one of the few opportunities for residents of the community to attend cultural programs at the time. Several of the original members of the First Congregational Church went on to be founding members of other St. Petersburg religious institutions. (Historic image courtesy Adele Gilmore.)

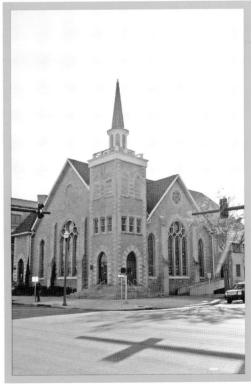

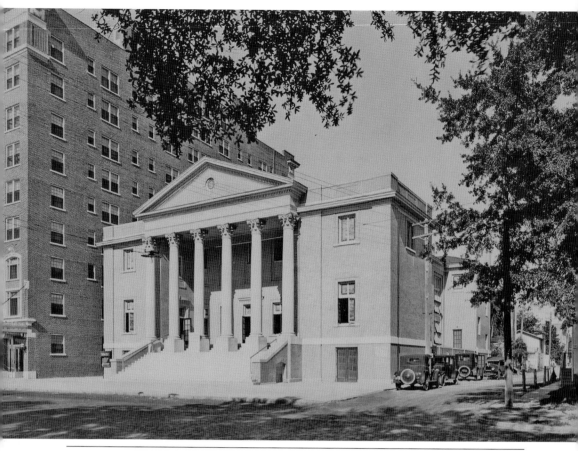

Built in 1924, the First Baptist Church is an exquisite example of the neoclassical style architecture, which is rare to St. Petersburg. Its Greek temple form is the sole example of a historic structure with this form in St. Petersburg, designating it a historic landmark. First organized in 1891, the church had many different locations but made this piece of land home in 1911. Currently, this building stands abandoned and empty. (Historic image courtesy Tampa–Hillsborough County Public Library System.)

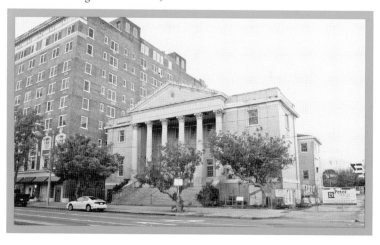

MIND, BODY, AND SPIRIT: FACILITIES SHAPING A COMMUNITY

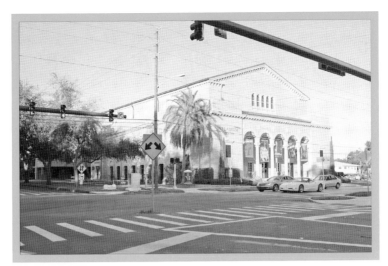

The First Church of Christ, Scientist, was built by the George A. Fuller Construction Company, one of the oldest and most distinguished companies in the United States. Architect Henry Lovell Cheney's influence and style mirrored that of Brunelleschi's Foundling Hospital in Florence, Italy, built in 1419. The structure served as a church for more than 75 years before becoming the Palladium Theatre in 1998 at the price of $575,000. The original 1926 Skinner organ is still inside. (Historic image courtesy Tampa–Hillsborough County Public Library System.)

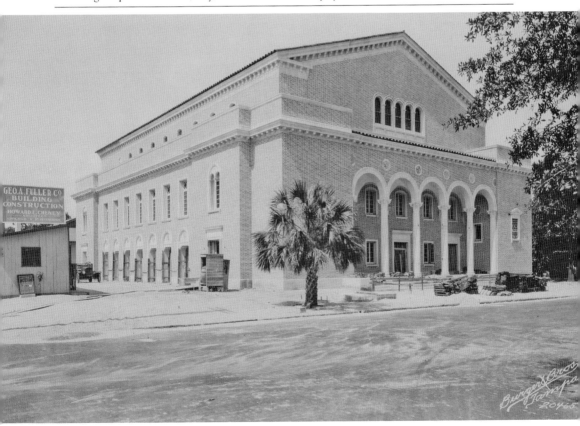

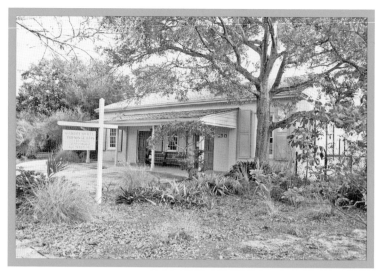

Built in 1941, the Friends Meeting House was a place where the Religious Society of Friends, or Quakers, held worship. The hallmark of a meetinghouse is extreme simplicity and the absence of any liturgical symbols. This small building, located on Nineteenth Avenue South, is still used by the Quakers today. It is also open to the community for activities such as yoga classes and is used as a voting precinct during elections. (Historic image courtesy Florida State Archives.)

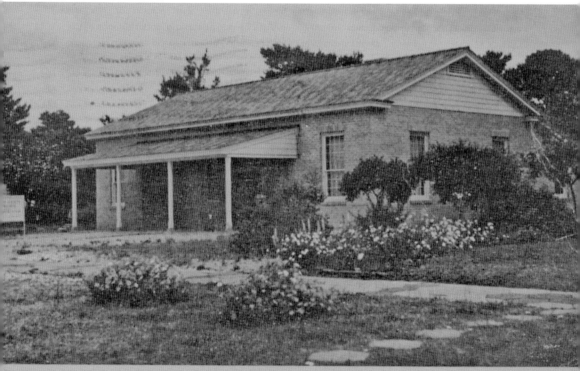

FRIENDS MEETING HOUSE BUILT 1941 ST. PETERSBURG, FLORIDA

MIND, BODY, AND SPIRIT: FACILITIES SHAPING A COMMUNITY

OUT AND ABOUT

WHERE THE PEOPLE PLAYED

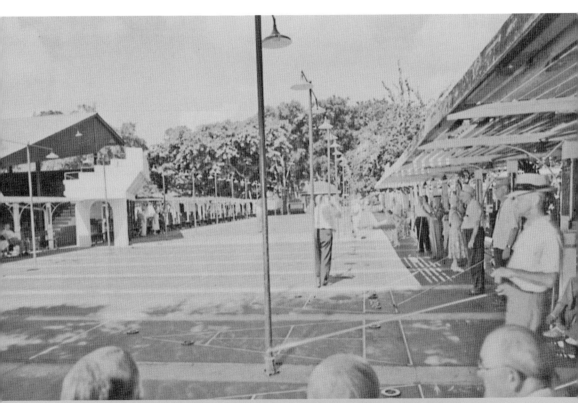

Significant for its association with the development of the tourist and leisure industries in St. Petersburg during the 1920s, the St. Petersburg Shuffleboard Club was organized in 1924. The club gained worldwide fame as "the World's Largest Shuffleboard Club" by virtue of having 110 playing courts and an annual membership of more than 5,000 from the 1930s through the 1960s. The club now has 65 courts, four masonry buildings, a steel and concrete grandstand, freestanding frame and metal porches, and hexagon block patios and walkways. (Image courtesy Adele Gilmore.)

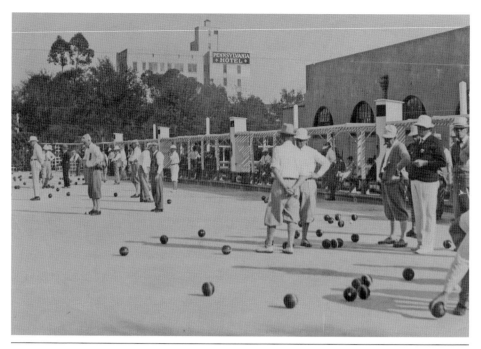

The St. Petersburg Lawn Bowling Club is the oldest, formally organized lawn bowling organization in Florida and the 10th oldest club in the United States. It is also the only location officially recognized by the American Lawn Bowls Association for the testing of bowls. The first National Open Lawn Bowling Winter Tournament was hosted by the St. Petersburg Lawn Bowling Club in 1926. Today the club has about 40 members and is listed on the National Register for Historic Places. (Historic image courtesy St. Petersburg Museum of History.)

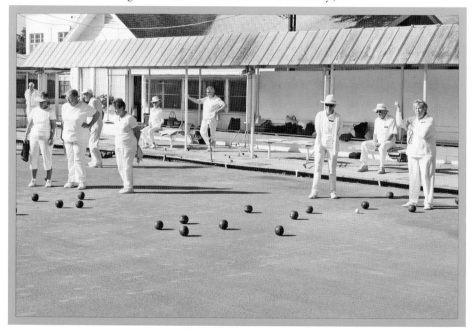

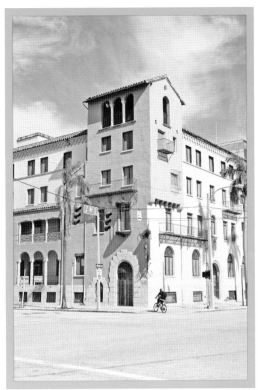

Built in 1927 for $550,000, the YMCA building is significant for its distinction as one of the largest community-funded projects in St. Petersburg. The YMCA is an excellent example of Mediterranean Revival–style architecture, and it retains significant interior features like a tile pool, cypress beams, and a tiled lobby. Under each gymnasium window on the second level, facing Second Avenue South, there is a decorative Spanish tile from Seville, Spain. Today this building stands vacant. (Historic image courtesy Heritage Village Archives and Library.)

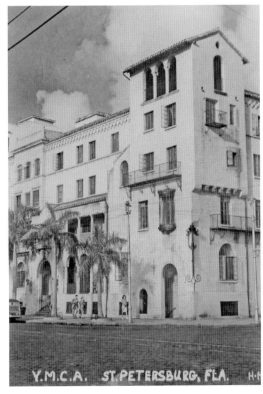

Y.M.C.A. ST. PETERSBURG, FLA.

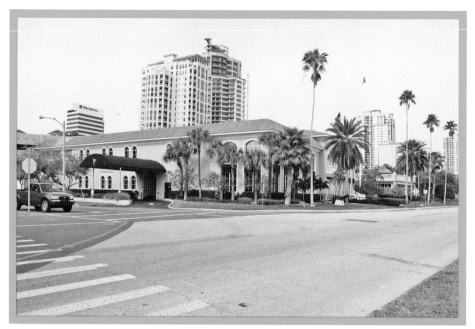

On October 29, 1909, the St. Petersburg Yacht Club was formed and helped to shape the downtown St. Petersburg waterfront into a recreational playground. It is one of the oldest yacht clubs in the United States and was completely renovated in 1992. Located at 11 Central Avenue, it is known as the "Sailing Capital of the South." There are more than 2,500 members to date. (Historic image courtesy Adele Gilmore.)

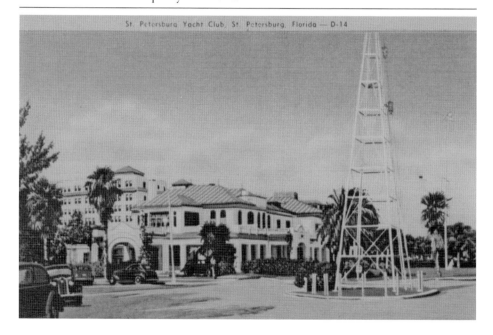

St. Petersburg Yacht Club, St. Petersburg, Florida — D-14

OUT AND ABOUT: WHERE THE PEOPLE PLAYED

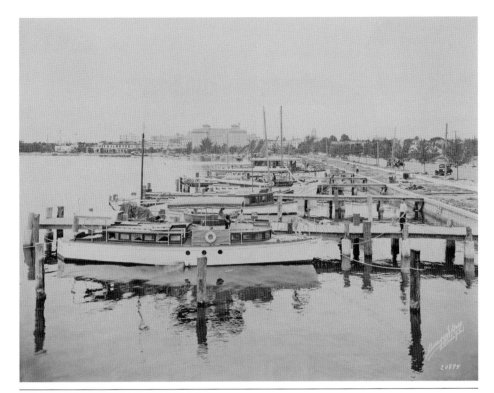

The photograph above was taken in 1926 at the St. Petersburg Yacht Basin looking at boat slip no. 85. The historic Soreno Hotel, which no longer stands, can be seen in the background. The now image not only shows a much more built up yacht basin but several additions to the downtown St. Petersburg skyline. (Historic image courtesy Tampa–Hillsborough County Public Library System.)

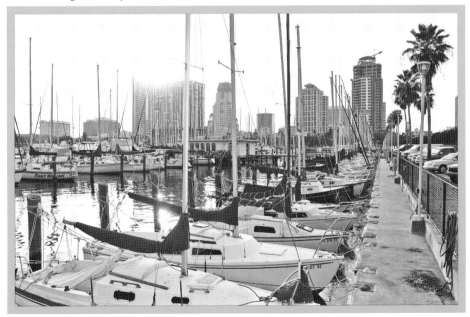

Sunken Gardens dates back to 1903, when George Turner Sr. began to convert a 5-acre tract of land into a botanical garden. It opened as a tourist attraction in 1935 and currently ranks as the oldest commercial tourist attraction on Florida's west coast and is one of the finest botanical gardens in the United States. The postcard at right, postmarked 1964, shows that the front entrance has not changed very much. In 1999, it was purchased by the City of St. Petersburg, using a voter-approved tax. (Historic image courtesy the author.)

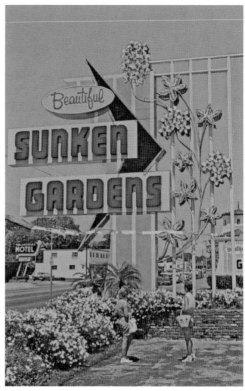

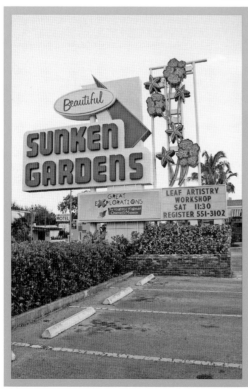

OUT AND ABOUT: WHERE THE PEOPLE PLAYED

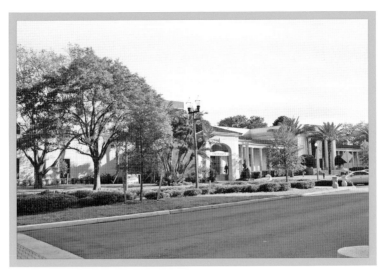

The Museum of Fine Arts was founded by Margaret Acheson Stuart and opened to the pubic in 1965. It is reflective of her vision of providing outstanding examples of world art in an inviting, elegant setting. It was designed by architect John Volk, who wanted to give the museum "a feeling of permanence." It has the only comprehensive art collection, extending from ancient times to the present, on Florida's west coast. (Historic image courtesy Florida State Archives.)

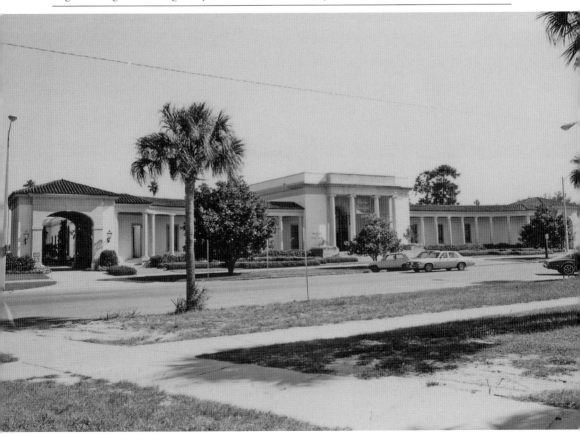

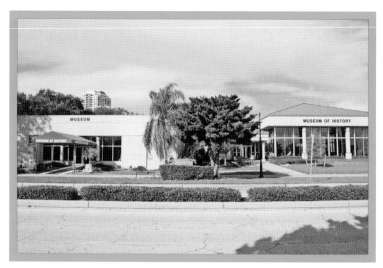

Founded in 1920 by Mary Wheeler Eaton, the St. Petersburg Museum of History was the first museum in St. Petersburg, and it is the third oldest in Florida. It has been refurbished over the years, including the significant addition in 1991 of the First Flight Gallery, commemorating the first commercial airline flight, which took place in 1914, between St. Petersburg and Tampa. The archives include 30,000 objects relating to the history of local tourism and business. (Historic image courtesy Florida State Archives.)

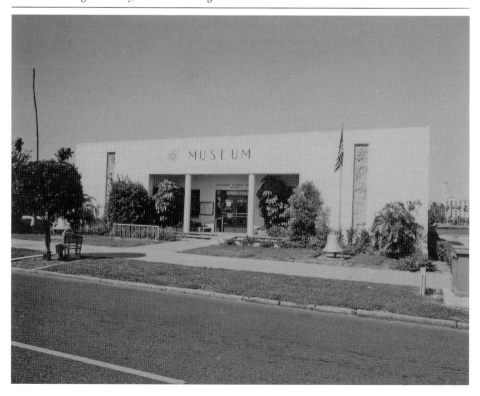

OUT AND ABOUT: WHERE THE PEOPLE PLAYED

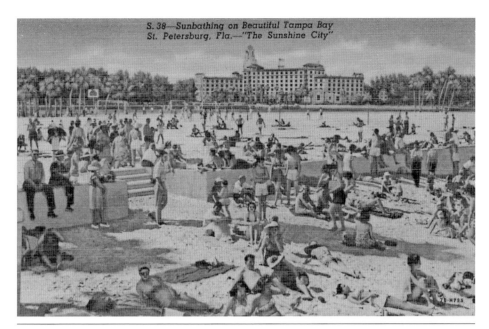

S. 38—Sunbathing on Beautiful Tampa Bay
St. Petersburg, Fla.—"The Sunshine City"

Spa Beach is located at the base of the St. Petersburg Pier. It once housed a toboggan slide and solarium for early tourists and residents. The postcard above shows Spa Beach with the 1925 Vinoy Hotel in the background. Today beach visitors can enjoy a fabulous view of the Pier or a relaxing afternoon of sunbathing, and they have access to an array of activities on the water such as paddleboats, jet skis, and other watercraft. (Historic image courtesy Heritage Village Archives and Library.)

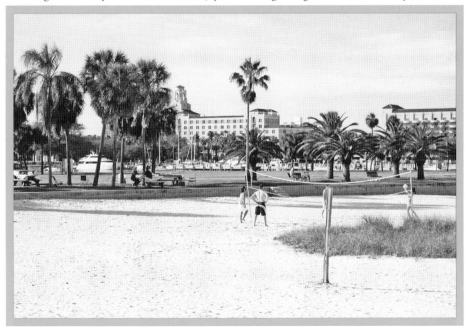

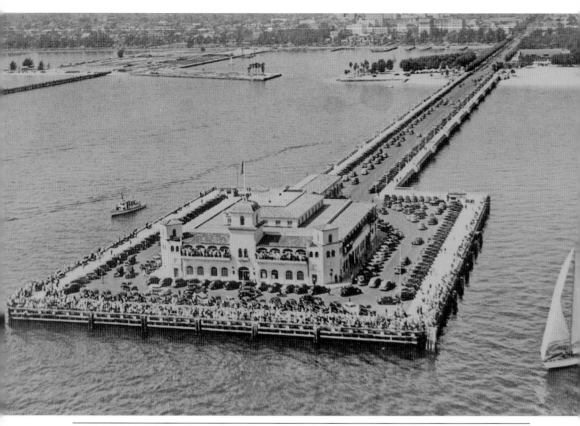

The 1926 "Million Dollar Pier" featured a central atrium, an open-air ballroom with terrazzo floors on the rooftop, and an observation deck. By 1967, the badly deteriorating pier was demolished, and the inverted pyramid St. Petersburg Pier (simply called the Pier by locals) was built. Its doors opened in 1973, and it remains a centerpiece and major tourist attraction in the St. Petersburg downtown today. (Both images courtesy City of St. Petersburg.)

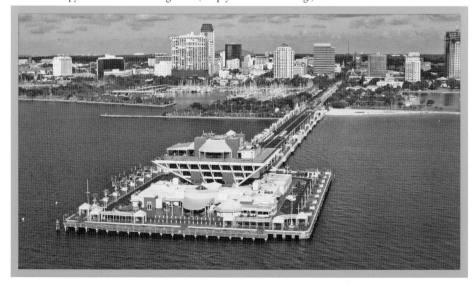

OUT AND ABOUT: WHERE THE PEOPLE PLAYED

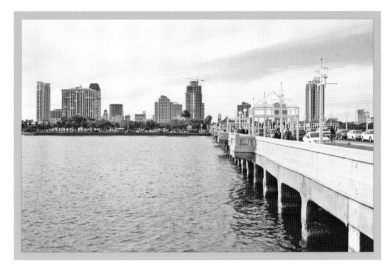

The view below from the Pier shows St. Petersburg when few buildings graced the skyline. Most notably on the left is the Bayfront Towers, condominiums that were built in 1975. Now, many structures along the St. Petersburg skyline offer residents and visitors alike the chance to enjoy spectacular views of Tampa Bay all the way to the Gulf of Mexico. (Historic image courtesy Florida State Archives.)

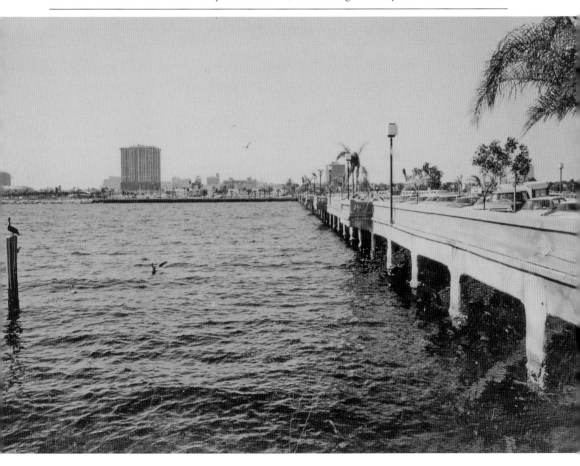

Charles R. Hall developed Lakewood Estates and Golf Course in the early 1920s. The roof of the Spanish-style clubhouse pictured below was designed to roll back and display the stars. In October 1970, it was destroyed by fire. In 2000–2001, the golf course and clubhouse underwent $2.5 million in renovations, and the club's name was changed to the St. Petersburg Country Club. (Historic image courtesy Florida State Archives.)

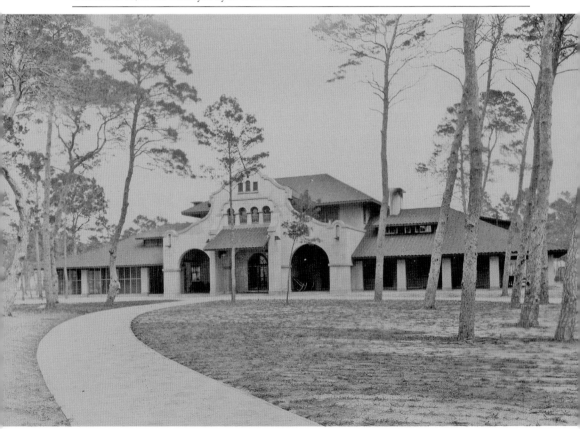

OUT AND ABOUT: WHERE THE PEOPLE PLAYED

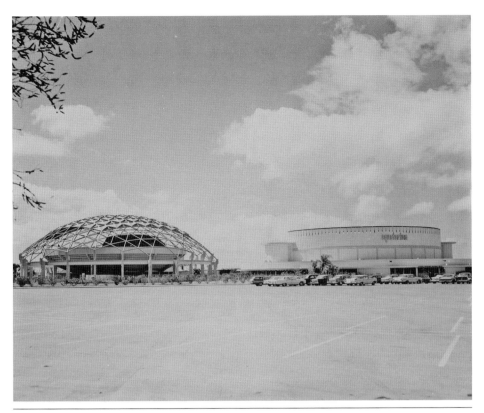

Marine Attractions, Inc., built the Aquatarium in 1964 on 17 acres of St. Pete Beach. The facility entertained crowds with trained porpoises, sea lions, and even pilot whales. In 1968, Frank Cannova, a local hotel owner, bought the Aquatarium just as tourism started to decline in the area due to the opening of Disney World. The Aquatarium eventually closed to make way for the Silver Sands Beach and Racquet Club Condominium. (Historic image courtesy Florida State Archives.)

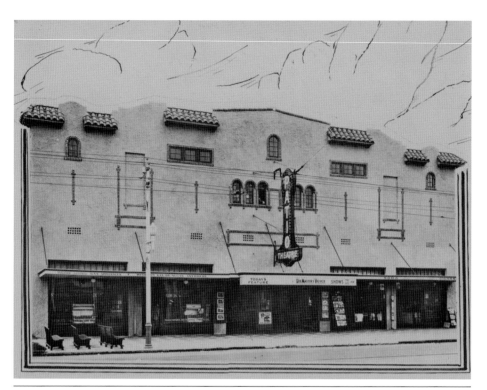

Shown above is the Patio Theatre, an old movie theater located at 1850 Central Avenue. This structure was later converted into the Extra Inning Ballpark Café. Extra Innings was the ultimate place for diehard sports fans and held about 1,000 people. Now this building stands vacant underneath the Interstate 275 overpass. (Historic image courtesy Tampa–Hillsborough County Public Library System.)

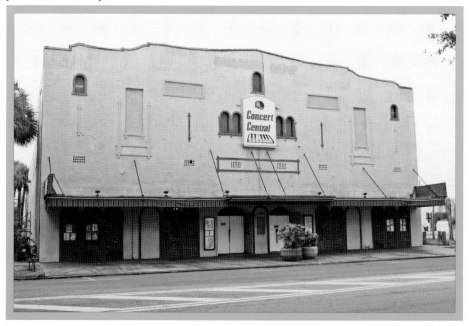

OUT AND ABOUT: WHERE THE PEOPLE PLAYED

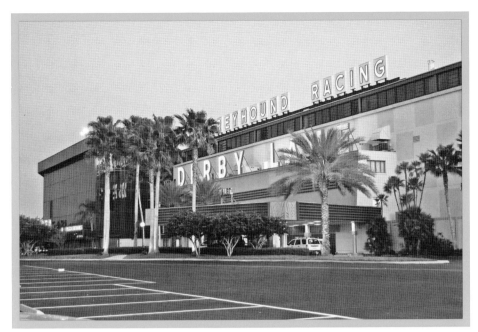

Derby Lane opened its doors in 1925 and is the oldest continuously operated greyhound track in the country. In the early 1920s, lumber entrepreneur T. L. Weaver sold one pine track to a group of local businessmen, who constructed a greyhound track. Unable to pay their outstanding balance, the men gave the track to the Weaver Lumber Company, and it has remained in the Weaver family ever since. (Historic image courtesy Adele Gilmore.)

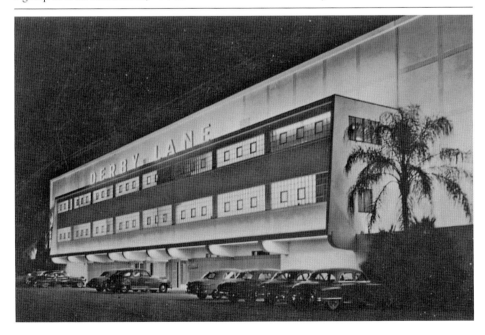

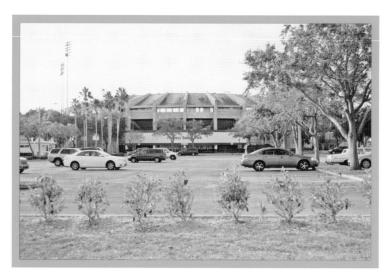

In 1914, Mayor Al Lang convinced the St. Louis Browns baseball team to train in his hometown of St. Petersburg. Because of this, St. Petersburg is said to be the birthplace of major-league spring training. Greats like Babe Ruth, Lou Gehrig, and Mickey Mantle all played here. In 1947, Al Lang Field was dedicated to the mayor. Progress Energy Park, built in 1997, was home to the Tampa Bay Rays from 1998 to 2008. (Historic image courtesy Tampa–Hillsborough County Public Library System.)

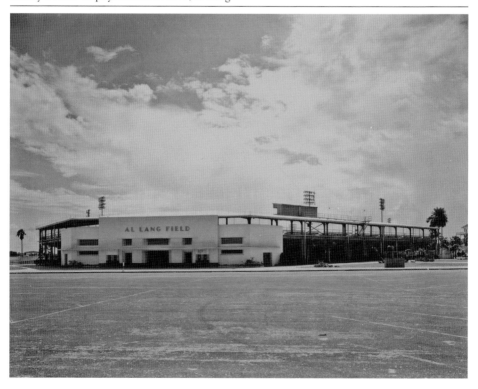

OUT AND ABOUT: WHERE THE PEOPLE PLAYED

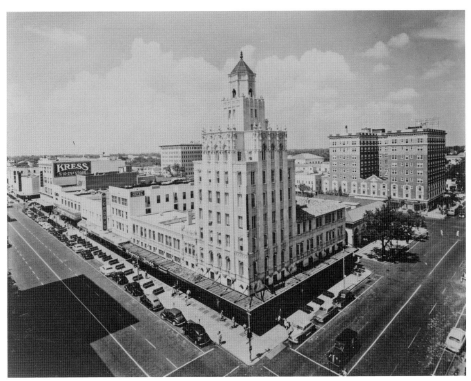

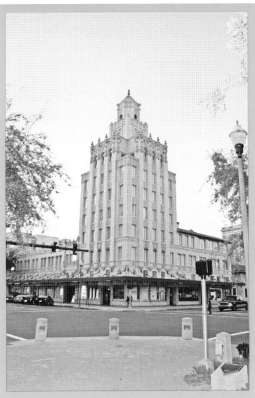

To many, the Snell Arcade, pictured above in 1950, is seen as architect C. Perry Snell's crowning achievement. Snell helped transform St. Petersburg during the development boom of the 1920s. The original arcade housed 10 stores on the ground floor, offices on the upper floors, and a nightclub on the third-floor terrace. Babe Ruth was one of the many patrons. In 2003, it was converted into a condominium with 11 residential units and seven commercial units. (Historic image courtesy Tampa–Hillsborough County Public Library System.)

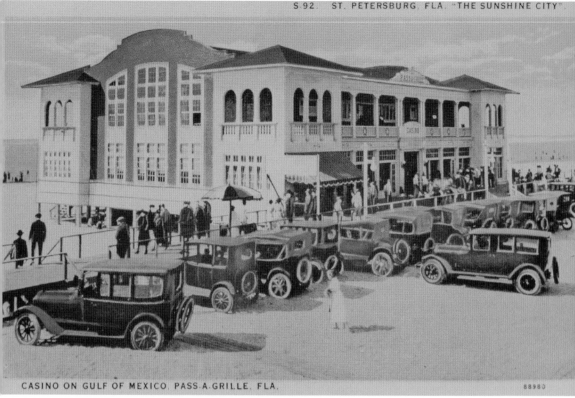

CASINO ON GULF OF MEXICO, PASS-A-GRILLE, FLA.

88980

Just down the road from St. Pete Beach, the Pass-A-Grille Casino was built in 1921 and had a bathhouse and a snack bar. Later additions included a second floor with hotel rooms, a dance hall, and a restaurant. It was then converted into a hotel but was destroyed by fire in 1967. The Paradise Grille, a concession stand, is now in its place. (Historic image courtesy the author.)

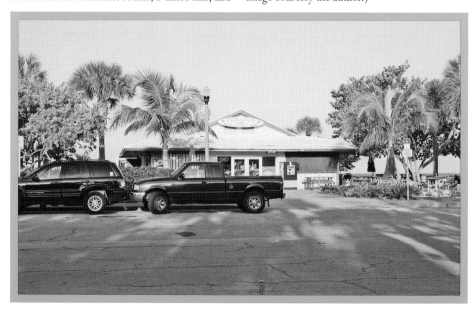

OUT AND ABOUT: WHERE THE PEOPLE PLAYED

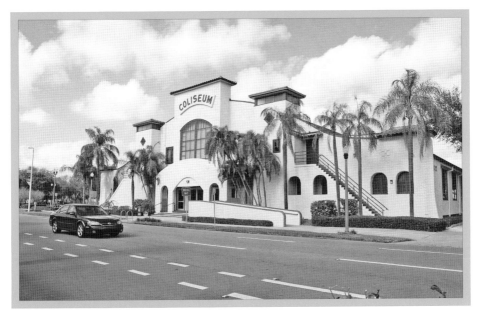

Located at 535 Fourth Avenue North, the Coliseum was built in 1924 and is pictured below in 1925. It was purchased by the City of St. Petersburg in 1989. Often called the "Finest Ballroom in the South," the Coliseum was a regular stop for performers such as Louis Armstrong, Cab Calloway, and Buddy Holly. It has undergone extensive renovations and today is still St. Petersburg's most unique multiuse facility. (Historic image courtesy Tampa–Hillsborough County Public Library System.)

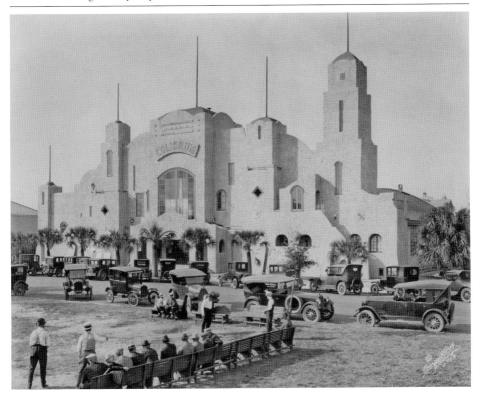

DISCOVER THOUSANDS OF LOCAL HISTORY BOOKS FEATURING MILLIONS OF VINTAGE IMAGES

Arcadia Publishing, the leading local history publisher in the United States, is committed to making history accessible and meaningful through publishing books that celebrate and preserve the heritage of America's people and places.

Find more books like this at
www.arcadiapublishing.com

Search for your hometown history, your old stomping grounds, and even your favorite sports team.